Practical HDR

Practical HDR

Second Edition

The complete guide to creating High Dynamic
Range images with your digital SLR

David Nightingale

Lewes

East Sussex BN7 2NS

www.ilex-press.com

Publisher: Alastair Campbell

Creative Director: Peter Bridgewater

Associate Publisher: Adam Juniper

Managing Editors: Natalia Price-Cabrera and Zara Larcombe

Editor: Tara Gallagher

Associate Editor: Steve Luck

Art Director: Julie Weir and James Hollywell

Senior Designer: Emily Harbison and Kate Haynes

Designer: Richard Wolfströme and Ginny Zeal

Colour Origination: Ivy Press Reprographics

British Library Cataloguing-in-Publication Data
A catalogue record for this book is available from
the British Library

ISBN: 978-1-907579-78-3

Printed and bound in China

10 9 8 7 6 5 4 3 2 1

Contents

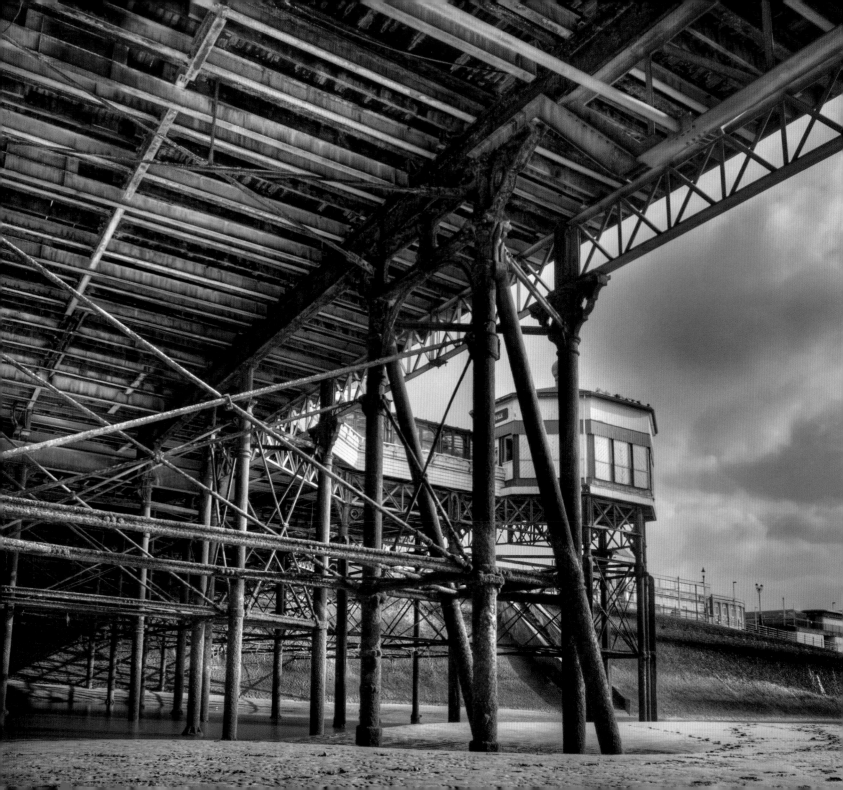

Introduction

When I started out in photography, one of the things I found most frustrating was that my camera seemed to have a totally different view of the world to me. Where I saw a glorious sunset, my camera saw an overexposed wash of pale colors; where I saw clouds floating over a beautiful landscape, my camera saw a flat white sky, or a dark foreground, or both; and backlit portraits would all end up as silhouettes. With practice, I learnt a variety of techniques that improved my photography: using exposure compensation, setting my camera to Manual, and using different metering patterns to assess a scene. In other words, I developed a better understanding of how to compensate for the various ways in which my camera's perception of the world was more limited than my own.

At the same time, I also learnt that there are some shots that you just can't take— at least not without using additional lighting, reflectors, neutral density graduated filters, and so on. These are the shots where the contrast is so high that some areas of the image will end up overexposed, underexposed, or both. The problem is that while our eyes can see a full range of tones in these high contrast scenes, our digital cameras cannot.

This problem isn't a new one, and the earliest photographers looked for different ways to record high contrast, or "high dynamic range" images. In the 1850s, Gustave Le Gray produced a number of dramatic seascapes constructed from two negatives—one exposed for the sea, the other for the sky. He cut both negatives along the horizon, then used the two parts to create a single photographic print. In this way he was able to capture all of the detail in the scene, which would have been impossible with a single exposure. Motivated by the same problem, Charles Wyckoff developed a wide dynamic range film composed of three layers, each of which had a different sensitivity to light. He used this to produce photographs of nuclear explosions, which first appeared on the cover of *Life* magazine in the 1940s.

But it wasn't until much more recently that what we now commonly refer to as High Dynamic Range, or HDR, photography began to develop. In 1985, Gregory Ward created the Radiance RGBE file format for HDR images—a format that is still in use today— while in 1993, Steve Mann reported creating a tone mapped image from a sequence of exposures of normal digital images. The idea was simple—shoot a sequence of exposures that covered the full brightness range of the image, and combine them into a single, high dynamic range picture that would contain detail in everything from the brightest highlight to the deepest, darkest shadow.

This sounds straightforward, but there are numerous issues that can make it far from easy. To start with, you need to be able to meter the scene to calculate the number of exposures to make sure to capture the entire dynamic range. You also need to know how to deal with any significant movement between the frames, and you have to understand how to create and "tone map" your images to create a final picture that meets your creative expectations. As you will see in this book, once you understand these issues, HDR imaging is a powerful technique that can be used to produce photographs that are simply not possible through any other means.

Chapter 1:
Understanding Dynamic Range

Real World Dynamic Range

One of the first things you learn as a photographer is that the way you perceive a scene is often quite different to how your camera evaluates and processes the same data. For example, a shot you intend as a backlit portrait may well end up as a silhouette, a shot of a brightly lit scene may end up looking too dark, and so on. In other words, the image you see is sometimes not the one you manage to take.

There are two main reasons for this. The first is that your camera will attempt to set an optimum exposure for a particular shot, so it will set the aperture or shutter speed, or both, to make sure that enough light hits the sensor to produce a well-exposed image.

The problem is, your camera assumes an average level of illumination for every shot you take, so if you shoot in a dark room, the image may well end up brighter than the original scene as your camera bases its exposure on an average level of illumination. By the same token, a shot of a person, backlit by a bright sky, may produce a shot with a beautifully exposed sky, but no detail in your subject's face— again because the camera works on the assumption that all pictures are taken under "average" lighting conditions.

The second reason your images may not end up as you intend them is because of the difference between the way in which you see things and how your camera records them. While you might see a

richly detailed landscape set against the backdrop of a bright, but cloudy sky, the camera will be likely to deliver a picture where the sky looks as you intended, but the foreground is too dark, or with a correctly exposed foreground and an overexposed, blank white sky. Worst of all, you might get an image with both a featureless sky and an overly dark foreground. In this instance, adjusting the exposure won't fix the problem, it will just present you with a different one. Increasing the exposure to compensate for an overly dark foreground will overexpose the sky still further, while decreasing the exposure to retain the detail in the sky will lead to an even darker foreground.

A correctly exposed sky with an overly dark foreground

A correctly exposed foreground with an overexposed sky

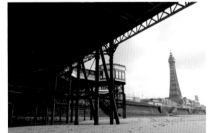

An image containing areas of under and overexposure

An HDR image allows you to combine the brightest and darkest parts of a scene that your camera wouldn't be able to record in a single shot.

The problem is that the "dynamic range" of the scene you are trying to photograph is larger than your camera can record. At its simplest, dynamic range is the ratio between the lightest and darkest tones in an image. This is often measured in EV (Exposure Value), which refers to the combinations of shutter speed and relative aperture that give the same exposure. Additional terms that are often used in this context are "f-stops" and "contrast ratio."

When we view a scene, we can perceive a range of between 10–14EV (or f-stops), and if we take into account the fact that our eyes can adjust to different levels of brightness this increases to around 24EV. But digital cameras can only record an EV range of 5–9 stops, so if the scene contains an EV range of around 9 or more, there is no combination of

aperture or shutter speed that will allow you to capture the entire dynamic range of the original scene. All you can do is optimize the exposure for the shadow detail or the highlight detail, but you will inevitably lose one or the other.

From a photographic point of view, there are three solutions. First, you can simply avoid taking shots where you know that the size of the EV range will compromise the quality of the final image. In the case of a landscape shot this might mean waiting until the balance of light between the brightest and darkest areas of the scene falls within a smaller EV range.

Second, you could use a graduated neutral density (ND) filter to darken the brightest areas of the image. These can darken a portion of an image in increments from 1–3EV and are

especially useful for landscape photography as the sky can often be a lot brighter than the foreground. However, the gradation on the filter is fixed, so it is generally only suitable if there is a clear "dividing line" between the light and dark areas of the scene— useful for a landscape with a flat horizon, but less useful for images where the bright and dark areas are irregularly shaped.

Finally, you can shoot a range of different exposures that record the detail in both the deepest shadows and the brightest highlights, and then combine them into an High Dynamic Range (HDR) image, which is clearly the key topic for the remainder of this book.

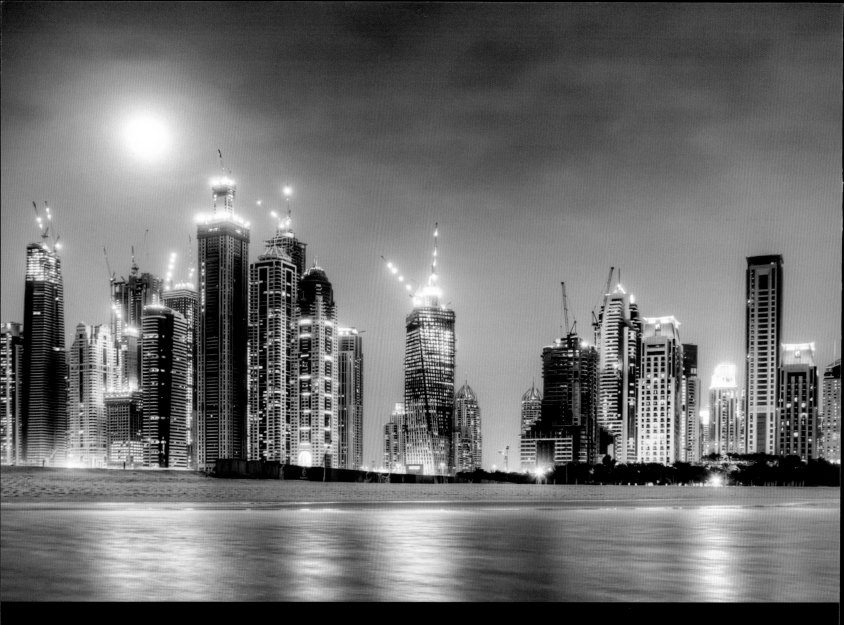

JPEG files distribute the data in a slightly different way to Raw files. While there is still a bias toward the highlight detail, the number of levels allocated to each area of brightness is more evenly distributed, as illustrated in the accompanying grid.

12-bit Raw file	Levels
1: Highlight areas	2048
2: Bright areas	1024
3: Midtones	512
4: Dark areas	256
5: Shadow areas	128

8-bit JPEG file	Levels
1: Highlight areas	69
2: Bright areas	50
3: Midtones	37
4: Dark areas	27
5: Shadow areas	20

Digital Sensors and Contrast Ratios

Your eyes and your camera's sensor respond to light in a similar way, with photons striking a receptor (either your retina or the photosites on the sensor). This generates a signal, the strength of which is proportional to the amount of photons striking the receptor within a given amount of time. With the eye, exposure to light is continuous, and the effect on the retina decays over time, but with a camera the effect is additive—the shutter opens, photons are collected in the photosites for a finite period of time, and then the shutter closes. At this point, the photons are "counted" to produce a digital signal indicating the amount of light that was received during the exposure.

The reason a typical digital camera can capture an EV range of between 5 and 9 stops is because each photosite on your camera's sensor has a specific capacity, and once it reaches the maximum limit the signal it outputs is the same, irrespective of how many further photons strike it. In other words, it's like a bucket: once it's full there is no way to add any further content. This is significant, as differences in brightness can only be recorded in terms of the differences in the number of recorded photons. For example, if the capacity of each photosite was a maximum of 1024 photons, then the theoretical maximum EV range it could

record would be 10EV (210 levels). In practice, this theoretical limit can never be reached as recording detail in the very darkest areas of an image is inaccurate due to the inherent noise that sensors generate. No analog-to-digital converter is sufficiently accurate to distinguish between single photons.

Another problem is that while a 12-bit Raw file is capable of recording a theoretical maximum of 4,096 levels of brightness, the amount of data allocated to the different levels of brightness within the scene varies, with half (2,048) allocated to the brightest areas, half of the remaining 2,048 allocated to the next brightest areas, half of the remaining 1,024 to the next, and so on, as outlined in the grid at left. This means consider-ably more data is used to record detail within the brighter areas of an image. With a normal photograph this isn't especially significant, but with an HDR image—especially one where you really want to maximize the amount of detail in all areas of the image—the shadow detail becomes much more significant. If you haven't recorded sufficient levels of detail in the darker areas the conversion process will struggle to produce a "clean" image, resulting in noise, banding, or other digital artifacts in the darker areas of the converted image.

Contrast ratios of other devices

Although it would be easy to think that the solution to dealing with high dynamic range images is simply to develop cameras with sensors that can record a higher dynamic range to start with, we also need to consider how our photographs will be displayed. Our cameras are capable of recording roughly 5–9EV, which equates to a contrast ratio of 32:1–512:1, but as noted, the dynamic range of an actual scene can be quite a bit higher; the EV range of a shot containing very bright highlights and very deep shadows could be around 14EV, which is a contrast ratio of 16,384:1. Even if our camera could record this level of data, there are very few ways in which we could display the image: a photographic print typically has a contrast ratio of around 300:1, while a standard computer monitor has a contrast ratio of approximately 500:1. So even if your camera could record a much larger EV range, most standard output devices are Low Dynamic Range devices and could not display it. There are a number of High Dynamic Range monitors that have a claimed contrast ratio of around 200,000:1, but these are incredibly expensive, and unlikely to be available to the domestic market any time soon.

Using and Understanding the Histogram

Understanding the histogram is essential to every stage of producing an HDR image. You will need to use your in-camera histogram to calculate the EV range you need to shoot; to evaluate the individual shots in a bracketed exposure sequence; to change a variety of settings when you convert your HDR images; and to judge images during any subsequent post-production. In short, it's an important tool that can provide invaluable feedback as you work your way through every stage of the HDR process.

We've already examined the relationship between the EV range of a scene and the dynamic range of your camera's sensor and, as noted, the former can often be larger than the latter, resulting in areas of over- or underexposure in your images. A related term is "tonal range," which basically refers to the range and distribution of the tones between the lightest and darkest areas of an image. For example, an image with a wide tonal range will include both dark and light areas (and a range of tones in between), whereas an image with a narrow tonal range will be predominantly composed of midtones. The range and distribution of tones is graphically represented using a histogram, which is a graph with two axes. The horizontal axis shows the distribution of tones from black (at the left) to white (at the right), while the height of the graph indicates the number of pixels at any given tonal value, so the higher the peak on a histogram, the more pixels are within the image at this point.

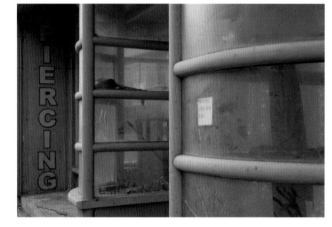

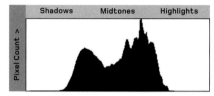

In this example you can see that the data is clumped toward the middle of the histogram. This indicates two things. First, it shows that the tonal range is reasonably narrow—there are no blacks or whites, so no deep shadows or bright highlights. In other words, the majority of the tones cover the midtone values. Second, it tells us that the EV range of the original scene was smaller than the dynamic range of the camera's sensor, as all the data within the original scene "fits" within the horizontal axis.

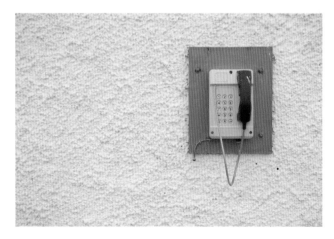

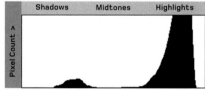

The entire EV range of the original scene has also been captured in this shot, but the shape of the histogram is very different to the first one. There is a large clump of data to the right of the histogram, and a much smaller clump toward the left. The large peak on the right represents the wall, while the smaller clump represents the darker areas of the phone on the red wooden board.

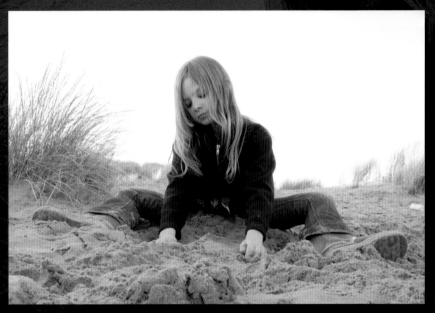

In this example, the histogram is butted up to the right edge. This indicates that a portion of the picture is over-exposed, and if you take a look at the original image you can see why. I set the exposure to record a good range of tones in the foreground, but because the EV range of the original scene was quite high, this caused the brightest areas of the image to be "clipped" from the histogram, meaning they ended up as pure white in the photograph.

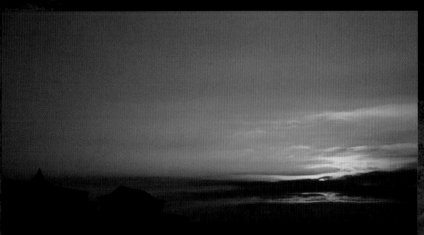

This image contains quite large areas of underexposed data, and the shadow and foreground detail have been lost. In this instance this is indicated by "clipping" at the left edge of the histogram, where a range of areas within the original capture are black. Increasing the exposure would shift the histogram to the right, and recover some shadow detail, but perhaps not all of it.

What all these examples demonstrate is that the histogram can provide invaluable data regarding your initial exposures and, in the case of your in-camera histogram, is an instant way to accurately assess both the EV range of the scene your are photographing and the tonal range your camera has captured.

By accurately assessing your histogram you can make sure your final HDR image contains a full tonal range.

In this example, both the shadow and highlight areas have been clipped, meaning there are areas of pure black and pure white in the image. This means the EV range of the original scene is considerably larger than the dynamic range of the camera's sensor. Adjusting the exposure to record more highlight detail would make the shadows worse, and vice versa.

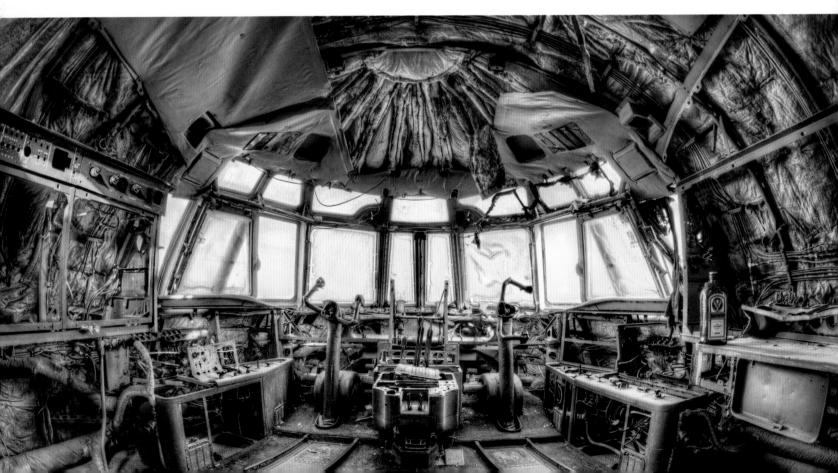

RGB and Brightness histograms

The histograms in the previous examples are all brightness histograms, which read the scene as a whole. However, some digital cameras allow you to switch to an RGB histogram that shows the three color channels (red, green, and blue) individually. An RGB histogram will often be more accurate as, while the brightness histogram might indicate that your exposure contains no shadow or highlight clipping, the RGB histogram might indicate that the highlight exposure for the green and blue channels is OK, but that the data in the red channel is overexposed, for example. Avoiding over- and underexposure is definitely one of the things you should aim for when shooting sequences of images to process into into an HDR image and anything that can aid you in avoiding exposure errors is something you should embrace.

An in-camera
RGB histogram

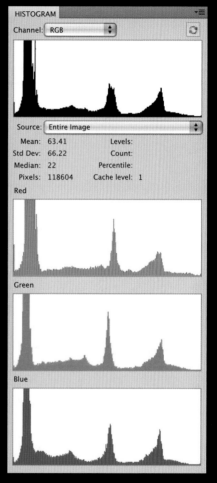

Histograms in Photoshop

When working in Photoshop, you can also assess your images using a histogram, by choosing *Window>Histogram* to open the Histogram Palette. The default histogram shows a brightness histogram, similar to the in-camera versions we just looked at, but you can also call up RGB histograms for your images.

To switch the display to show the RGB histogram, click the dropdown menu at the top-right of the histogram palette and select All Channels View. This will display the three channel histograms, as well as the original composite display. This can be especially useful during post-production to prevent you inadvertently clipping the detail in either the shadows or highlights of an individual channel. To make sure this doesn't happen, switch your camera to the RGB histogram as often as possible, and make sure that you get into the habit of routinely previewing your exposures as you shoot them. If you notice any under- or overexposure in one or more of the three channels, adjust your exposure and take the shot again.

Photoshop's
"All Channels View"
histogram

Photoshop's default
brightness histogram

HDRI and Tone Mapping Explained

When the EV range of a scene is larger than the dynamic range of the camera you have no option other than to accept that some of the detail cannot be recorded in a single image, and you will have to sacrifice shadow detail, highlight detail, or both. In many cases, this isn't a problem—simply set your exposure to make sure that the areas of the scene you are most interested in are are exposed adequately. In this example, I set my exposure to capture the sunset and the bright reflections in the water, allowing the young woman in the fore-ground to become a silhouette. This works well, and the loss of detail creates a more subtle, enigmatic image.

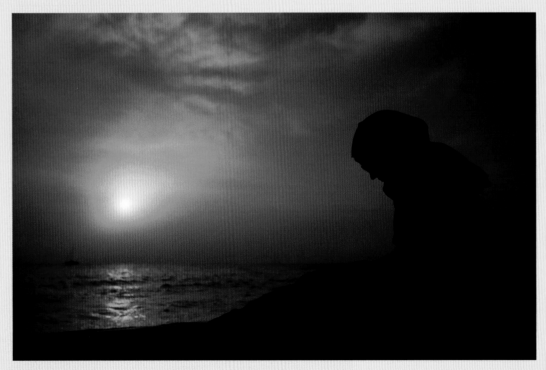

Sunset in Dubai

Let's look at another example, this time a view underneath a pier. Here, the EV range of the original scene is about 5EV (or stops) larger than my camera's dynamic range, so a sequence of images from -2EV to +3EV is required to successfully capture the entire dynamic range. The histograms of the lightest and darkest images show the sequence as a whole covers the entire EV range of the scene, with no clipped highlights in the darkest exposure, and no clipped shadows in the lightest.

Having done this, the next step is to combine, or convert, this sequence into a single High Dynamic Range (HDR) image. The term "High Dynamic Range"—or "High Dynamic Range Image" (HDRI)—is often used to label a particular style of picture, but, technically, this name is incorrect. As an HDR image is a 32-bit image it cannot be displayed or printed on conventional low dynamic range (LDR) devices such as computer monitors or printers. In other words, most—if not all—of the HDR images you have seen (including those in this book) are actually LDR images, albeit created using a variety of HDR techniques.

Indeed, HDR images themselves are visually quite dull, at least when displayed on a standard monitor or the printed page. This is because we can only display a portion of the full dynamic range, so a "pure" 32-bit HDR file of the pier doesn't really look any better than any of the original images in the exposure sequence, and still displays a substantial amount of clipping in both the shadow and highlight areas.

So, while an HDR image may contain all the data from the original scene—in both the shadow and highlight areas—we can't see all of the detail if we are viewing it on a conventional LDR device. This means creating an HDR file is only a part of the story, and this story isn't complete until we convert it back into an LDR image using a process called "tone mapping."

The histogram for the darkest exposure (-2EV)

The histogram for the lightest exposure (+3EV)

-2EV

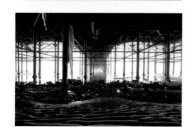

-1EV

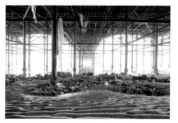

Metered exposure

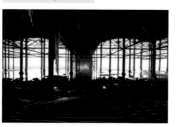

+1EV

+2EV

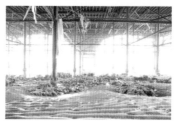

+3EV

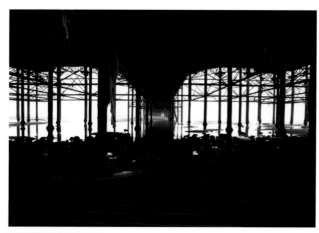

32-bit HDR file

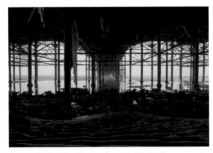

Converted using Photoshop Highlight Compression

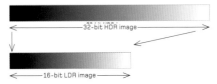

Tone mapping
a 32-bit HDR file

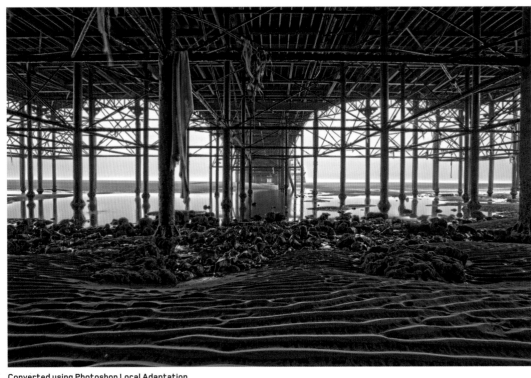

Converted using Photoshop Local Adaptation

Tone mapping

At its most basic, tonemapping a 32-bit HDR image simply involves compressing the image data into a range that can be printed or displayed. If we use one of Photoshop's basic tone mapping methods, Highlight Compression, (as discussed in chapter four) we can compress this HDR picture of the pier into a 16-bit (or 8-bit) file that contains a full range of tones in both the shadow and highlight areas (above right).

As you can see though, converting the image in this way still doesn't produce an especially good result. While we do now have a full range of tones in both the shadow and highlight areas of the image, the underside of the pier and the foreground are both still dark, and the sky and brighter areas of the image lack any detail.

This is because this particular form of tone mapping applies a global algorithm to the 32-bit HDR image, so every pixel is converted—or "mapped"—in the same way. Essentially, the luminance of each pixel is altered in a uniform way to make sure that all the data fits into the smaller luminance range of the LDR image.

While these global forms of tone mapping can produce good results when the variance in luminance is evenly distributed, a form of "local" tone mapping will often produce a better result. Local tone mapping adjusts each pixel in relation to the value of the surrounding pixels in the image, rather than treating them all the same. The math behind this process is extremely complex, but the result is an increase to the local contrast in different areas of an image by unequal amounts. As the final version of the pier image reveals (above left), using the localized tone mapping algorithms in Photoshop's Local Adaptation mode has produced a considerably more striking picture (above).

The original image

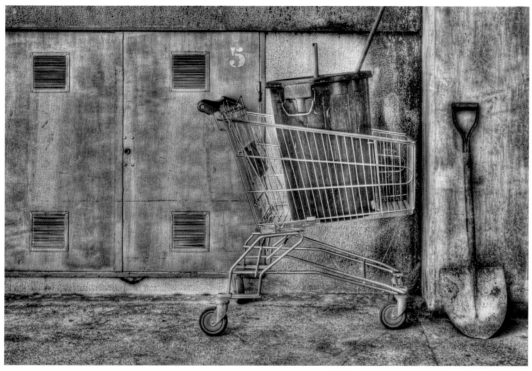

A tone mapped HDR image

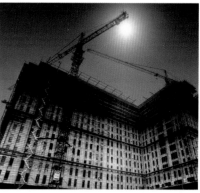

Increased local contrast

In this Local Adaptation example, there is now a high degree of contrast in the foreground of the image and the underside of the pier—areas that were quite dark when converted using Photoshop's simpler, global Highlight Compression method. There is also much greater detail and contrast in the brighter areas of the image. Put simply, using a local tone mapping algorithm has produced a much better image.

Throughout this book, the majority of the techniques will concentrate on local tone mapping algorithms to produce an LDR image, though the extent to which this effect is applied will vary, depending on the result we are looking for.

The image of the shopping cart and trash can (above), looks more like an illustration than a photograph once the HDR file has been converted into an LDR image. The final image was produced from a single Raw file (a technique covered in chapter six) and was processed to maximize the local contrast. In the original shot, the trash can is very dark, but in the tone mapped version it shares the same tonal range as other sections of the image. In other words, the naturally occurring global contrast in the original—where some areas of the image are clearly darker than others—has been all but removed in the final, tone mapped image.

By comparison, the tone mapped image of a building and cranes—which required seven bracketed exposures to capture the entire dynamic range—looks far more natural. Although the dynamic range of the original scene was very high, less local contrast was introduced at the tonemapping stage, allowing the darker areas to remain quite dark and the lighter areas to retain a higher amount of brightness. As a result, the final image appears more photorealistic than the shopping cart, although both images would still be labeled "HDR."

Chapter 2:
Shooting for HDR

Camera Settings and Equipment

Having explained the basic principles of HDR photography, it's time to turn our attention to the practicalities of the process; the equipment you need, how to meter a scene with a larger EV range than your camera's sensor, and how to shoot a bracketed sequence of exposures to maximize the quality of your final image. The good news is that you don't need a great deal of kit to produce stunning HDR images—in fact, you may already have everything you need to get started.

For HDR photography, you can use either a compact, or a digital SLR camera, but it must let you adjust the shutter speed while holding the aperture constant. As you are probably aware, there are three ways to alter the exposure of a photograph; by changing the aperture, the shutter speed, or the ISO. When shooting HDR sequences, you only want to adjust the shutter speed between exposures. Altering the aperture varies the depth of field, so if you shoot a sequence of images at different apertures, the content of each image will be different, making it difficult, if not impossible, to combine the sequence into a single image.

If you look at the three images below (taken at aperture settings of f/4, f/8, and f/16) you will see that while they are shots of the same scene, the content is very different. In this instance, this isn't a bracketed sequence—each is based around the metered exposure—but they demonstrate the point; it would be impossible to generate a coherent HDR image from a sequence of images that each had a different depth of field.

Shot at f/4

Shot at f/8

Shot at f/16

Varying the ISO will also produce images that have different content, although in this instance it will be in terms of the amount of noise within the image. If you wanted to shoot a three image sequence with a 2EV (or 2-stop) interval between the frames, for example, you would need to shoot at ISO 100 for the darkest shot, ISO 400 for the metered exposure, and ISO 1600 for the lightest shot. As you may have already found, the higher the ISO, the noisier the image, with red,

green, and blue speckles starting to appear in the image. Even if you were using the best digital SLR currently available, there would still be appreciably more noise in the shot taken at ISO 1600 than either of the other two exposures. Again, if you tried to combine this sequence to create an HDR image, the result wouldn't be great, so stick to adjusting the shutter speed—and only the shutter speed—when you shoot a sequence of images for HDR.

Shoot Raw

Most digital SLRs, bridge, and high-end superzoom and compact cameras now support the Raw file format. This format supports 12- or even 14-bit uncompressed data, (much more than the 8-bits of compressed data for a JPEG), and provides the best possible image quality you can get from your camera. If you can, shoot in the Raw file format.

Digital SLR
Digital SLRs are great for HDR photography as they offer full manual control over your exposures.

Superzoom and Bridge
Most superzoom and bridge cameras offer Aperture Priority and Manual modes, so are also good for HDR imaging.

High-end compact
Only a few high-end compact cameras offer the controls you need for HDR photography.

Auto-bracketing

Virtually all digital SLRs, bridge, and some compact digital cameras, let you automatically bracket your exposures, letting you shoot a minimum of three frames, with one at the metered exposure, one that is underexposed, and one that is overexposed. To use auto-bracketing for an HDR sequence you should make sure that you select Aperture Priority mode, as this will fix the aperture and vary the shutter speed to change the exposure during the sequence.

If the EV range of the original scene can be captured using an auto-bracketed sequence (this will depend on the EV range of the scene and the level of control your camera offers) then this is the best method to use. Not only will your camera shoot the sequence as quickly as possible—minimizing any potential subject movement between exposures—but the likelihood that you will move the camera's position during the sequence is also reduced.

Exposure compensation

If your camera doesn't have an auto-bracketing facility, it may well have an exposure compensation feature, which can also be used to shoot an HDR sequence. Set your exposure compensation to underexpose by -2EV and take a shot, then readjust your camera to the metered exposure (0EV) and take a second shot. Finally, dial in +2EV to take the lightest shot in the sequence. Nearly every compact camera—and most digital SLRs—limits you to a range of ±2EV exposure compensation, but this is often sufficiently wide to capture a basic HDR sequence.

Shooting in Manual mode

An alternative to using auto-bracketing or exposure compensation is to switch your camera to its Manual mode and change the shutter speed between each exposure. This isn't ideal—it takes longer, is prone to error, and may well result in you moving the camera between exposures—but may be the only viable alternative if the EV range of the original scene is very high.

In-camera HDR

A number of digital SLRs and compact cameras offer an in-camera HDR mode. In this mode the camera will take two or three exposures up to 3EV apart. The camera's processor combines the images and creates a single optimized image that contains a greater dynamic range than would be possible with one exposure.

Tripod

Remote release

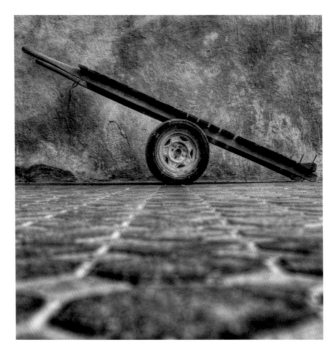

Promote Control

Tripod

Although all you really need to shoot a sequence of images for HDR work is a camera that can vary its shutter speed, there are other pieces of equipment that could be considered. These start with a tripod, which many photographers already consider an essential part of their kit. All of the HDR programs we will be discussing later in this book incorporate algorithms that will attempt to align the images from an auto-bracketed sequence. This makes it possible to shoot a handheld sequence of images, especially when shooting a relatively small number of exposures using auto-bracketing, but it doesn't always work. Even if you think you can keep your camera relatively steady, I would still recommend using a tripod to lock your camera into position. Sturdier models often produce better results—especially if you need to alter any of the settings on your camera during the exposure sequence—but the bottom line is any tripod is better than no tripod.

Remote release

A cable, or remote release, will also help reduce the risk of you inadvertently moving your camera during an exposure sequence. This is especially important when one or more shots in the sequence will be taken with a long exposure, as any camera movement will inevitably cause some degree of camera shake.

If you don't have a remote release—or your camera doesn't have the facility to use one—try using the self-timer instead. Again, this will minimize the chances of you moving your camera either between or during your various exposures.

Lens hood

A lens hood is incredibly useful when shooting HDR sequences as it will reduce the likelihood of your final image containing any lens flare. Flare is especially problematic in HDR as the process of constructing the images often involves maximizing the contrast within an image. As such, any flare in an exposure sequence will also be maximized, which should be avoided.

Promote Control

The Promote Control remote control allows you to set as many bracketed exposures as you wish at virtually any EV spacing variation, offering much greater bracketing flexibilty than even the highest specification digital SLRs usually allow. This flexibility helps to create exceptionally smooth color gradations in HDR imagery for more realistic, natural-looking results. The control also allows you to set the Mirror Up function on your camera to make sure you have blur-free images. As well as helping with HDR images, the Promote Control can also be used in the creation of time-lapse sequences, or even a combination of time-lapse and HDR images.

If you don't have a tripod, or don't have one with you, try bracing your camera against the ground, a nearby wall, or other object. The key consideration is keeping your camera as still as possible, both during and between exposures.

For the seven-shot sequence I used to create this image of a handcart, I simply rested the camera on the ground. This had the added benefit of producing a more creative shot than I would have done if the camera had been higher off the ground.

For low-light photography
a tripod is essential—not
just for HDR.

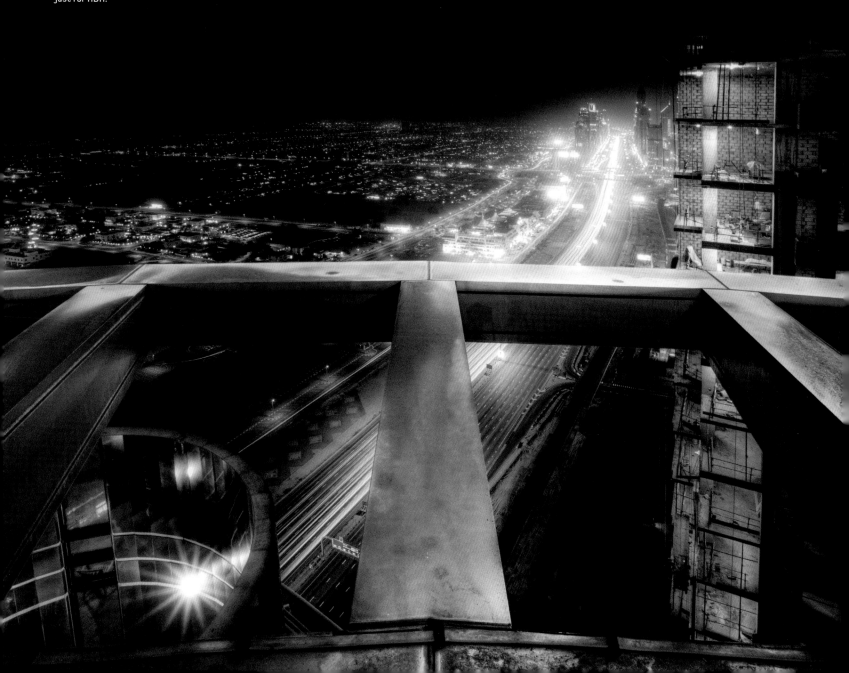

Metering the Dynamic Range of a Scene

One of the key stages in creating an HDR image is to make sure that the sequence of images you shoot captures the entire dynamic range of the original scene, so the lightest image captures a full range of tones in the shadow areas, and the darkest image doesn't clip any of the highlight detail. If you don't achieve this at the capture stage, your final HDR image will inevitably contain clipped shadows, highlights, or both.

In chapter six we will be discussing how to use HDR techniques to enhance a low contrast scene, where the entire dynamic range could be captured in a single shot. In these cases all you need to do is shoot a set of three auto-bracketed exposures (with an EV spacing of 1-2EV) based around the metered exposure.

In cases when the dynamic range isn't especially high, and just a bit larger than can be captured in a single shot, shooting an auto-bracketed sequence of three images will probably also be sufficient. If you look at the three images and histograms of the metal structure in the sea (below), you can see that the metered exposure almost captures the full dynamic range, with only minor clipping of the shadow detail. In this situation, having shot the metered exposure and checked the histogram, you could be confident that a three-shot auto-bracketed sequence would be sufficient to capture a full range of tones in both the shadow and highlight areas.

However, when the EV range is significantly larger than the camera's

dynamic range, things get a bit more complicated. If we take a look at the sequence of images that were used to construct the crane image on page 21, you can see that the dynamic range of the original scene was very high— around 10EV larger than my camera's dynamic range.

In this instance, an auto-bracketed sequence of three shots would not be enough to capture the entire dynamic range, so you need to evaluate the scene—prior to shooting the sequence—to determine the correct exposure for your lightest and darkest image. Then decide how many images you wll need to shoot between the two extremes.

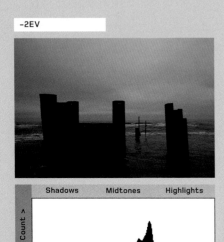

−2EV

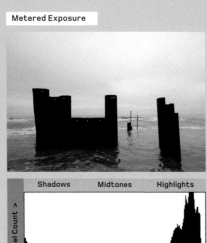

Metered Exposure

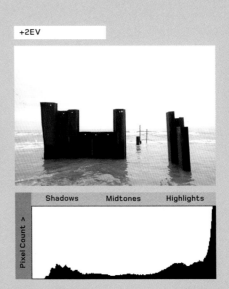

+2EV

Shadows	Midtones	Highlights

Pixel Count >

Shadows	Midtones	Highlights

Pixel Count >

Shadows	Midtones	Highlights

Pixel Count >

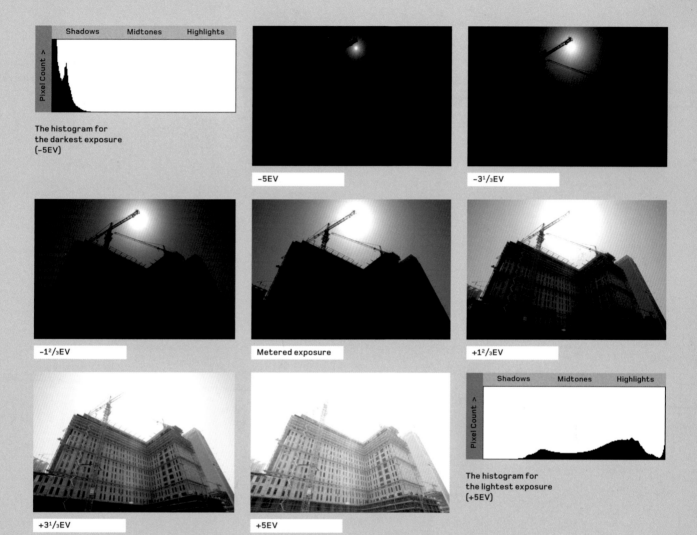

The histogram for the darkest exposure (−5EV)

−5EV

−3¹/₃EV

−1²/₃EV

Metered exposure

+1²/₃EV

+3¹/₃EV

+5EV

The histogram for the lightest exposure (+5EV)

A Sekonic spot meter

Using a spot meter

The easiest way to assess a scene is to use a spot meter—either a handheld meter, or the spot metering function in your camera, if it has it. To meter the darkest and lightest areas of the original scene, enter the aperture you are going to use (Aperture Priority mode is good for this), then meter each area, recording the indicated shutter speed for both. If the darkest area of the scene requires a shutter speed of 1/4 sec, for example, and the lightest area needs a 1/125 sec exposure, this indicates there are 6 stops (a 6EV gap) between these two extremes. Therefore, you would need to shoot seven exposures with a 1EV gap between them, or four using a 2EV spacing. Switch your camera to Manual mode, set the aperture, and shoot the sequence. Start with either the lightest or darkest image and manually adjust the shutter speed between exposures until you have shot the entire sequence.

Trial and Error

If you don't have a spot meter, or a spot metering option built into your camera, you can use a process of trial and error to determine the exposures you need. Switch your camera to Manual mode and adjust the aperture and shutter speed to the metered exposure that the camera suggests. Adjust the shutter speed to 2EV below its current setting (if the metered exposure is 1/60 sec, change it to 1/250 sec, for example), and take a shot. Check your histogram for highlight clipping, and if there is any, increase the shutter speed by a further 2 stops (2EV) and take a second shot. Again, check the histogram, and if the image still isn't dark enough, repeat the process until you reach a point where the highlights are not clipped. Once you do, make a note of the settings as this will be the darkest exposure in your image sequence.

Now, repeat the process to determine the shutter speed you need for your brightest shot (the shadow detail), this time increasing the shutter speed and checking for clipping at the opposite end of the histogram. When there is no clipping, you have found the settings for the lightest exposure. You can now shoot a sequence of images, starting with the lightest and adjusting the shutter speed until you reach the setting for the darkest shot.

Optimum Exposure

On the face of it, both of these histograms (below) look fairly similar, and both indicate there is no loss of shadow detail. However, because digital sensors record far less detail in the shadow areas of an image, you should make sure that the left most edge of your histogram for the lightest exposure isn't close to or touching the leftmost edge of the display.

So, although both of these histograms show there is no clipping, the first one (A) is a better starting point for an HDR sequence.

A

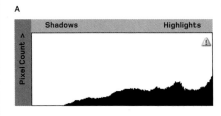

B

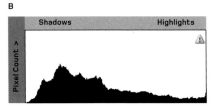

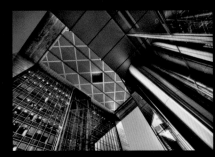

This seven-shot sequence of the DIFC (Dubai International Financial Center) is a typical example of shooting a series of images specifically for HDR. If you take a look at the histogram for the darkest image, you will see that a considerable amount of shadow detail has been lost (indicated by the left edge of the graph going "off the scale"), but there are no blown highlights at the right.

Likewise, if you examine the histogram for the lightest (+3EV) image in the sequence, you will see that although the entire sky is blown out—along with many other lighter areas—a full range of tones has been captured in the shadows. The images between these extremes fill the gaps and, in this instance, the intermediary images were spaced 1 stop (1EV) apart. As you can see from the combined histogram, the dynamic range of the original scene is almost 12 stops (12EV), which is far beyond the capabilities of anything other than dedicated high dynamic range imaging equipment.

Having shot my initial sequence of seven frames, I was able to produce a tone mapped image containing a full range of tones in both the brightest and darkest areas of the image, with no visible noise, even in the darkest areas.

Shooting a Bracketed Exposure Sequence

-3EV

-2EV

-1EV

Metered exposure

+1EV

+2EV

+3EV

The histogram for the darkest exposure (-3EV)

The histogram for the lightest exposure (+3EV)

Combined histogram

Shadows Midtones Highlights

Pixel Count >

Exposure spacing

Although there is no hard and fast rule about how far apart you should space the individual exposures in a bracketed sequence, there are some benefits to shooting a sequence with a spacing of 1EV rather than 2EV.

To explain this point, here's another sequence of images, ranging from -3EV to +3EV, taken at 1EV increments. As you can see from the histograms for the lightest and darkest images, the sequence more than covers the dynamic range of this scene, but how many of these shots are strictly necessary, and what would be the optimal EV spacing for a sequence of images covering this EV range?

To answer this, the following tone mapped images were created within Photomatix Pro. All four versions were created using the most extreme settings to emphasize any differences, although it should be noted that these extreme settings will inevitably introduce some noise into the tone mapped image irrespective of any other factors.

As you can see, there isn't a huge difference between the images constructed using a 1EV spacing (in both the five-shot and seven-shot sequences), but both of the three-shot sequences are noticeably degraded, especially the one constructed using the ±3EV images from the sequence. Put simply, shooting a sequence using a smaller EV interval between the different exposures will minimize the noise in your final image, and ultimately produce a better result.

-3EV

-2EV

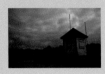
-1EV

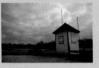
Metered exposure

+1EV

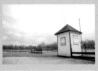
+2EV

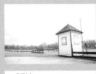
+3EV

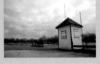

Histogram for the darkest image

Histogram for the lightest image

▶ Detail of image constructed using three images from the original sequence: -2EV, the metered exposure, and +2EV

▶▶ Detail of image constructed using three images from the original sequence: -3EV, the metered exposure, and +3EV

▶ Detail of image constructed from five images: -2 EV, -1EV, the metered exposure, +1EV, and +2EV

▶▶ Detail of image constructed using all seven images from the original sequence

Alignment

As well as making sure that you shoot enough images to cover the entire dynamic range of the original scene, the content of each frame ideally needs to be identical to the other frames in the sequence, especially in terms of alignment. In these three images of a small hut beside a lake, the position of the camera changed slightly with each exposure. The difference isn't huge,

but the tone mapped result created from these three images is totally unacceptable due to the misalignment of the various elements.

Fortunately, all of the programs we will be looking at in this book offer ways in which such misalignments can be corrected. They all operate in a similar fashion; comparing the content of each frame as the initial HDR image is created, and adjusting the perspective, rotation,

and scale so the sequential images are aligned as accurately as possible. In a second tone mapped version of the hut, the source images were aligned using Photomatix Pro, and there are now no traces of the original misalignment.

While most HDR generators will do a good job of correcting alignment problems, you should still aim to avoid this problem when you shoot your initial sequence. This is because each image in a sequence needs to be moved relative to the other frames to correct the misalignment, and the various adjustments will invariably mean that your final HDR image will need to be cropped:

Turn off autofocus (AF)

Most modern cameras now have sophisticated autofocus (AF) modes that usually provide sharp results. However, when shooting a series of shots to create an HDR image, it's possible, if left on autofocus, that the camera will refocus during the sequence, resulting in parts of the HDR image appearing soft. To avoid this, switch to manual focus, set up the shot so that you're happy with the point of focus, and shoot the sequence.

Set White Balance

If you're shooting Raw you'll have the opportunity to adjust the white balance setting on your images in post-production, before merging to HDR, but with some software this may involve having to convert the Raw files to TIFFs first. If you shoot with Auto White Balance (AWB) you may experience color shifts between frames, so the best option is to shoot a white or gray card and use a custom white balance setting before shooting the sequence.

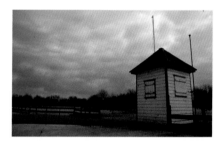

-2EV

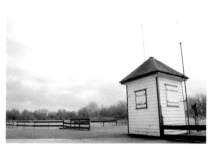

Metered exposure

+2EV

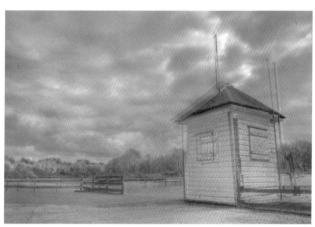

The result of misaligning the source images

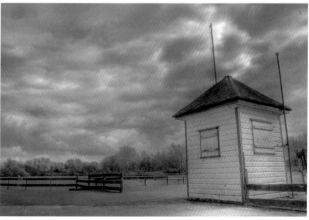

The alignment-corrected image

Ghosting

While alignment problems are caused by your camera moving between exposures, ghosting is caused by objects in the scene moving while you make your sequence of exposures. In the hut image, for example, there is a bird in flight, which appears in the top-right corner of the frame. Because the bird changed position while I shot the initial seven-shot sequence, it appears in the final tone mapped images as a "ghost."

Ghosting used to be harder to correct than misalignment, but the latest versions of HDR software are more able to cope with the problem. However, you are better off avoiding it (particularly if the ghosted area fills a significant amount of the frame). There are two ways in which this can be achieved—the simplest, and most obvious, is to avoid shooting scenes that contain any movement. However, this might not be possible, or you might simply not notice that something moved, such as the bird in this image.

If you know that something moved—or suspect something *might* have moved—the answer is to shoot more than one sequence of images. This will give you a range of images to choose from at each exposure setting in the sequence, rather than being limited to one set of images. When you come to construct your HDR image you can choose those images where the movement is either absent or minimal.

When even this isn't possible, there are still ways in which ghosting can be removed, although as this can often be a time-consuming process, it's much better to avoid the problem whenever possible.

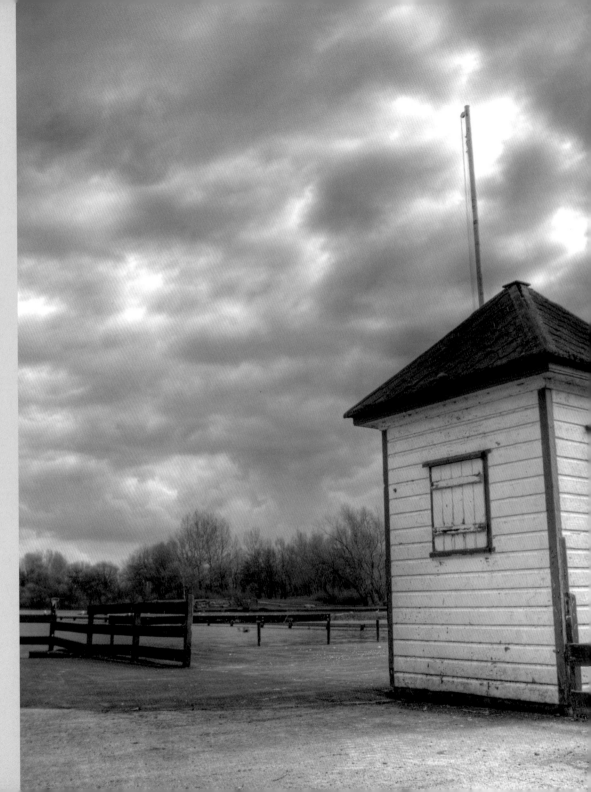

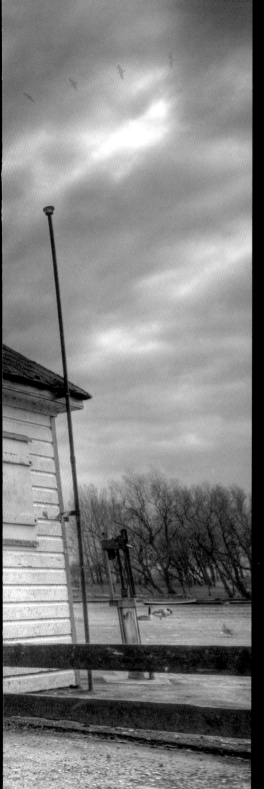

CHECKLIST: Shooting for HDR

Use a tripod	Although most HDR programs include an automatic method of aligning multiple exposures, they aren't always reliable, so it's a good idea to shoot your original sequence using a tripod. Take care not to move the camera between shots and, if you have one, use a remote release or your camera's self-timer.
Number of exposures	For the best results, evaluate the dynamic range of a scene using a spot meter to measure the brightest and darkest areas, and calculate your exposure sequence accordingly. If you don't have a spot meter you can use your histogram to determine your start and end exposures.
Disable AF and AWB	In order to avoid the camera switching focus halfway through the exposure sequence, turn off autofocus (AF) and compose the shot using manual focus. Similarly, to avoid color shifts between frames, set a custom white balance rather than relying on Auto White Balance (AWB).
Exposure spacing	There is no hard and fast rule about how far apart you should space the individual exposures in a bracketed sequence, but an increment of one to two stops is recommended. Differences of less than one stop needlessly replicate data, while increments greater than two stops risks a loss of data.
Auto-bracketing	Most cameras allow you to shoot an automatic sequence of three bracketed exposures, although some high-end digital SLRs allow more. If the dynamic range of the scene can be captured within three shots, you should use this function to minimize the chance of misaligned images, rather than manually altering your camera's settings.
Manual bracketing	If you need to change your camera's settings manually, use the shutter speed or your camera's exposure compensation feature. Don't adjust the aperture as this will change the depth of field and create alignment problems.
Shoot quickly	If the scene you are recording doesn't contain any moving components then the speed at which you take your bracketed exposures doesn't matter. However, if the scene contains rapidly moving components such as people, birds, vehicles, and so on, these cannot be recorded—at least not reliably. With scenes containing slow-moving elements such as clouds, the faster you shoot, the more likely they are to be in much the same place throughout the sequence.
Exposing for the shadow detail	The two most important shots within a bracketed sequence shot specifically for HDR, are the lightest and the darkest. The darkest shot is relatively straightforward—you just need to make sure that you haven't blown the highlights—but the lightest shot is a bit trickier. Make sure that the histogram contains some space at its leftmost edge to capture the full range of shadow detail.

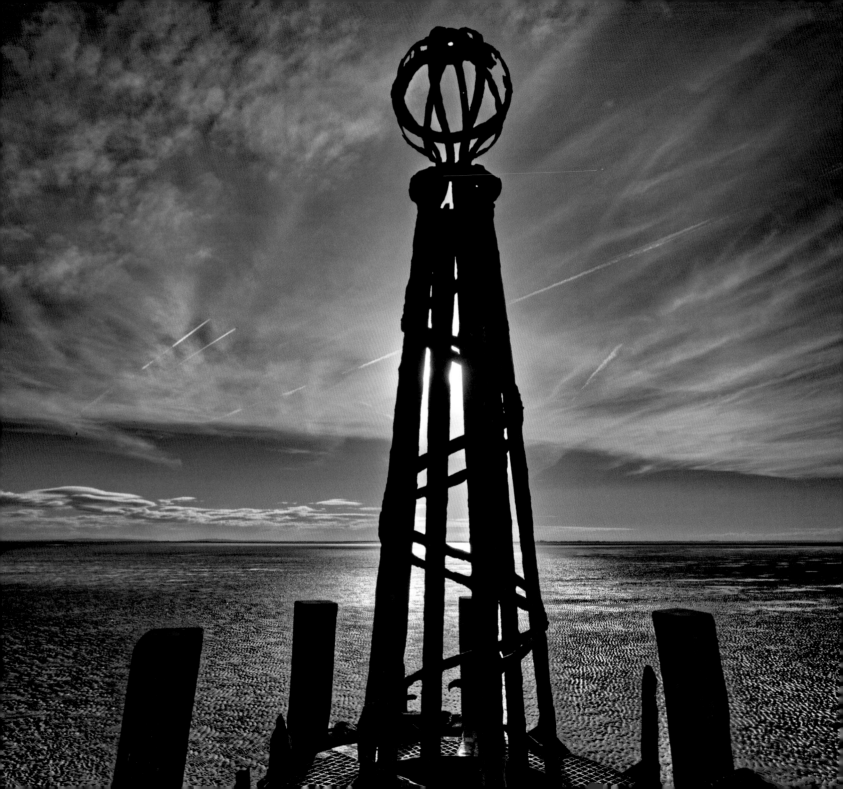

Chapter 3:
Merging Your Bracketed Sequence

HDR Software: The Options

As I mentioned in the introduction, while the history of HDR photography can be traced back to the exposure-blending techniques developed by Gustave Le Gray in the 1850s, it wasn't until earlier this century that HDR software became more widely available to photographers; Photomatix was first released in 2003, followed by FDRTools in 2004, and it wasn't until 2005 that even the most basic HDR functionality was added to Photoshop.

A few years down the line and Photomatix Pro has reached version 4, FDRTools Advanced is at version 2.4, and Adobe has made huge improvements to its HDR processing with Photoshop CS5 and its Merge to HDR Pro command. In addition, there is now a whole range of other programs available, perhaps the most significant of which are Nik software's HDR Efex Pro, Unified Color's HDR Expose, and Oloneo's PhotoEngine (although the latter is Windows only). There's even an app for the iPhone called HDR Pro.

Nik is a long-established software company that has created some excellent digital imaging products, and its foray into HDR imaging has caused great interest. Unified Color and Oloneo are newer companies specializing at present in HDR software. What all these programs share is their ability to combine a bracketed sequence of exposures into a single 32-bit HDR image, and tone map it into a 16-bit or 8-bit LDR image that can be viewed or printed on a range of traditional devices. However, the way in which each program accomplishes these tasks is quite different, and each provides a varying degree of functionality at each stage of the process.

It would be great if I could now tell you that I am going to take a detailed look at all the different programs that are available to you, but rather than provide a short summary of each it is more useful to take a more detailed look at some of the more popular programs; Adobe Photoshop, HDR Expose, Photomatix Pro, HDR Efex Pro, and Oloneo PhotoEngine. All have their strengths, and all can be used to create stunning images. In addition to their strengths, it's equally important to be aware that they all have their weaknesses, and all five do some things slightly less well than the others. I will cover these in more detail in subsequent chapters. In this section I will provide an overview of the features they share and how they differ, in terms of how they can be used to both generate and tone map your images.

If you have read any other books on HDR imaging, you might have noticed that most of them often contain a side-by-side visual comparison from two or more programs, showing the same HDR image processed using different software. I'm going to avoid this, because I don't feel it is especially helpful, for two significant reasons. The first is that working with HDR images is a two-stage process that involves generating an HDR image that you subsequently tone map. As HDR images cannot be viewed on conventional devices prior to tone mapping, this stage of the process can't be illustrated on the printed page, or on most computer screens, so comparisons between different programs at the HDR generation stage are wholly redundant.

The second, equally significant reason is that each of these program works well in some circumstances but less well in others. Photomatix Pro, for example, can often produce the most interesting results overall, but it can have problems controlling the evenness of the lighting, and can introduce halos around objects that are placed against a lighter background. Both Photoshop and FDRTools, on the other hand, often perform better in these situations, so any direct comparison based on how each of these programs converts a single sequence of images is likely to be misleading rather than informative; it will only illustrate the common ground they share rather than exemplifying their strengths. The bottom line is every image sequence is different, and no one program will deliver the "best" result in all situations.

So, we need to accept from the outset that each of the programs discussed has its strengths and weaknesses. While Photomatix Pro is perhaps the most established, HDR Efex Pro has some very useful features and an excellent interface. HDR Expose is simple to use and has won many fans, while FDRTools, although not perhaps the most intuitive program, can also produce good results. Photoshop's Merge to HDR Pro has come a long way since its last incarnation, and if you already have, or are intending to upgrade to CS5, this may offer everything you need. Your choice of program will depend on a variety of factors. These include the style of HDR image you wish to produce, the nature of the original scene, the extent to which there is movement within and between exposures, and so on. For this reason I would definitely recommend that you download the demos of all five programs, so you can try each one out before you buy.

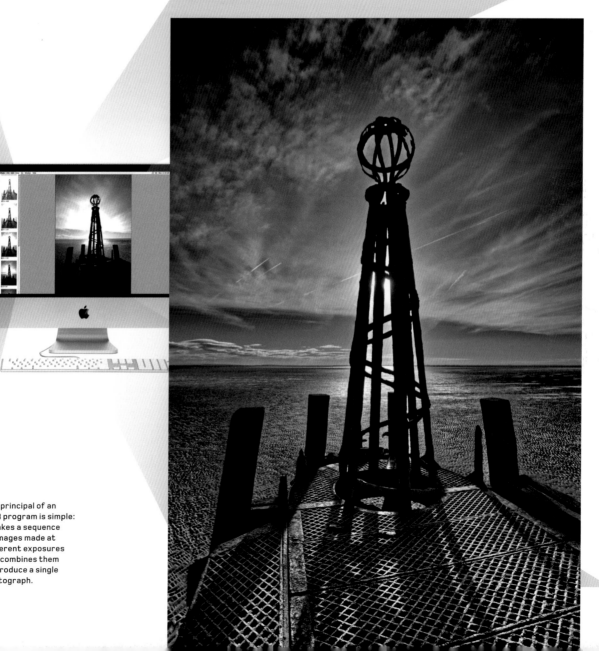

The principal of an HDR program is simple: it takes a sequence of images made at different exposures and combines them to produce a single photograph.

Pre-processing Raw Files

When reviewing a sequence of images shot for HDR, you may find that there are a number of issues you'd like to address before going on to merge the images in your chosen HDR software. Two of the most common ones are chromatic aberration and white balance. In both of these cases, if not addressed during pre-processing, the enhancing effects of the HDR process may well exacerbate the problems, resulting in the specific instances of chromatic aberration and white balance—wildly accentuated purple fringing and unacceptable color casts.

Although chromatic aberration and white balance are the two likeliest candidates for pre-processing, other issues to address are, potentially, dust spots, soft images, lens distortion, and excessive noise.

What software to use?

If you feel your images would benefit from some form of pre-processing, the next step is deciding at what stage this should be done. Some HDR programs perform certain pre-processing tasks. Photomatix Pro, for example, allows you to fix chromatic aberration and adjust white balance. Although the white balance options are good (including a custom input box), the chromatic aberration control is either on or off, so it doesn't offer the same level of control as you find in Photoshop ACR (Adobe Camera Raw), Lightroom, or Aperture, for example. Photomatix Pro also offers a Noise Reduction option that offers varying degrees of control

depending on how the images are selected. HDR Express has a white balance dropper, which you can use to set the white point, as well as sliders that will "warm up" or "cool down," the image, or introduce a greenish or reddish tint, while Oloneo PhotoEngine also offers white balance adjustment tools that you can apply before the image is tone mapped. Apart from these adjustments, there's usually no other pre-processing option at all. So if you want to fix other issues, such as removing dust spots or sharpening a sequence of soft images, you'll have to do these in a Raw editor. Furthermore, it's likely that the algorithms used for noise reduction, fixing chromatic aberration, and so on, are likely to be more sophisticated in dedicated Raw editors than in HDR software.

Establishing a workflow

Before you make any pre-processing corrections in your Raw editor, you need to ascertain whether or not your specific HDR software "reads" any changes you make to the Raw images. When you make adjustments to Raw images in Raw conversion software, the pixels remain untouched—the adjustments exist as a set of instructions that are contained in an associate XMP or sidecar file. Whether these instructions are carried over and implemented by the HDR software depends not only on the HDR software you're using, but also on the Raw editor. For example Photoshop's Merge to HDR Pro will read the XMP files associated with Raw files and implement any

adjustments that you've made to them. On the other hand, if you're using Photomatix Pro as a standalone program, and browse to, then import the amended Raw files, the software won't read any associated XMP files. It simply takes the Raw data and converts the files to TIFFs before creating the 32-bit HDR file, essentially losing any Raw adjustments you have made. HDR Express and PhotoEngine work in the same way as Photomatix Pro, while Nik HDR Efex Pro cannot read Raw files at all. In such cases, in order to retain the adjustments you've made to the Raw files with a Raw editor such as Lightroom, you need to manually save the amended Raw files as 16-bit TIFFs before importing and merging them in the HDR software.

To test whether or not your HDR software reads XMP instructions, make an obvious change to a Raw sequence—convert it to black and white for example—and open the saved Raw files in the HDR software. If the HDR image is rendered black and white, you'll know the answer.

Finally, because an increasing number of HDR programs such as HDR Efex Pro and Photomatix Pro exist as plugins for Raw editors such as Aperture and Lightroom, the workflow is streamlined for you. Once you've adjusted the Raw files Lightroom or Aperture automatically convert the files to 16-bit TIFFs (with any amendments incorporated) when you export to the HDR software. This saves you having to manually save the Raw files as TIFFs.

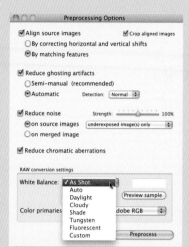

▲
Photomatix Pro Photomatix Pro's Preprocessing Options, which are made available once you have selected your images, vary slightly depending on whether they've been selected via Bridge or exported from Lightroom, and whether the files are TIFFs or Raw.

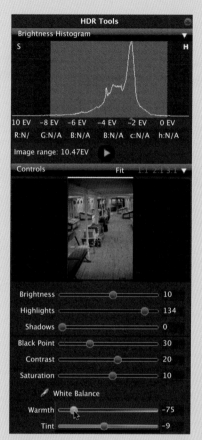

▲
HDR Express HDR Express has an eye-dropper tool for setting a white point, and Warmth and Tint sliders to fine-tune the image's white balance before the image is tone mapped.

▲
Adobe Camera Raw Although some of the more popular HDR programs allow you to make adjustments, such as white balance, either before merging the source images or before tone mapping, they don't offer the same level of options as Adobe's ACR Raw editor, for example, which allows for excellent control over issues such as Sharpening and Noise Reduction. Using Synchronize (see page 45) when fixing issues such as dust spots, means you only need to make the correction once.

▶
PhotoEngine After PhotoEngine has created the 32-bit HDR file, you are presented with, among other controls, menus and commands to adjust the white balance before the image is finally tone mapped.

▲
Lightroom Performing any pre-processing amendments in a Raw editor such as Lightroom also gives you the opportunity to apply specific lens and camera profiles to your sequence of Raw images before they are merged in the HDR software.

Adobe Photoshop CS5

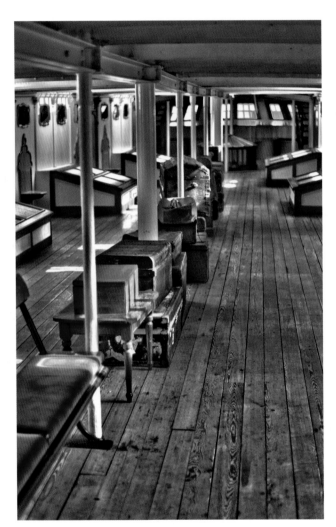

This image was created by merging a sequence of three Raw files in Photoshop's Merge to HDR Pro command. A significant improvement on Photoshop's earlier HDR command, Merge to HDR Pro offers a good level of control, allowing for more creative HDR effects.

If you don't already have a copy of Photoshop, then I wouldn't recommend purchasing it simply to produce HDR images: there are dedicated HDR programs that do as good a job, if not better, at a fraction of the price. That said, if you own a copy of Photoshop CS5 you will definitely find its Merge to HDR Pro function a very credible option, providing much greater control than the previous Merge to HDR option. Having said that, Photomatix Pro, PhotoEngine, HDR Efex Pro, and to a lesser extent HDR Express, provide greater control and a greater variety of HDR results, particularly at the more artistic end of the spectrum.

Photoshop is capable of producing excellent realistic HDR images, and in terms of producing an initial HDR image, it's the only program here that allows you to modify your Raw files prior to constructing the HDR image. Photoshop offers four tone mapping operators— Local Adaptation, Exposure and Gamma, Equalize Histogram, and Highlight Compression. Photomatix Pro, however, has just two, and HDR Express and HDR Efex Pro only offer one, though only Local Adaptation and Exposure and Gamma are useful for photography, and only the Local Adaptation method offers an acceptable level of control over the appearance of the tone mapped image. Photoshop's biggest strength though, is its capacity to produce photorealistic images from an exposure sequence with a high EV range, as you will see in the next chapter.

Generating a 32-bit HDR image

Creating a 32-bit HDR file in Photoshop is a relatively straightforward process that you can initiate from the file menu (*File>Automate>Merge to HDR Pro*) (1). This will present you with a dialog box that lets you select the images you want to work with (2). The most efficient way to do this is to use the Browse button to navigate to the images, but you can also open the files first then use the Add Open Files button. If you're using a computer with a large amount of RAM (in excess of 4GB) then this second option works well, but as the process of generating the HDR file is very processor-intensive I would recommend the Browse option. An alternative way to select your images is via the Browser. In the Browser window, highlight the sequence of thumbnails by holding down the Shift key. Once you've highlighted all the thumbnail files, go to *Tools>Photoshop>Merge to HDR Pro*. Once you have selected your images, you can press OK and wait for Photoshop to create the HDR image.

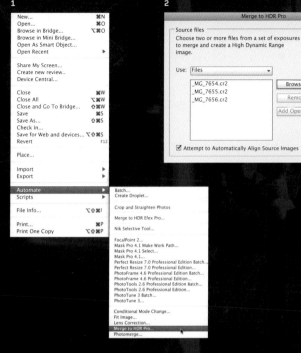

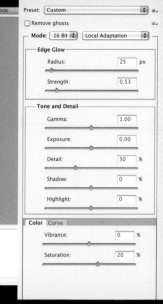

At this stage, if you are working with a large number of originals and don't have a powerful computer, it can take some time for Photoshop to generate the 32–bit HDR. Once the process is complete, you will be presented with another dialog box (3).

There are three options for you at this stage. First, you can deselect any of the original images by using the checkbox below each preview image. Second, you can set the bit-depth of the generated file. If you want to process the sequence of images using the Local Adaptation mapping option, selecting 16 bit gives you access to a good number of controls (4). These are grouped under Edge Glow,

Tones and Details, and two additional tabs Color and Curve. We will look in more detail at the controls on offer in the next chapter, but there are two features that instantly stand out and make the software much more user friendly. The first is the Preset options pull-down menu (5), which provides thirteen preset HDR styles to choose from. Simply select one from the menu and Photoshop applies the relevant settings, which you can then fine-tune using the sliders.

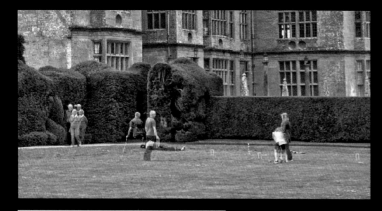
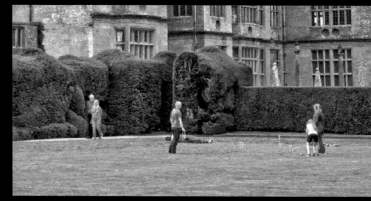

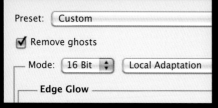

☑ EV +1.68 ☑ EV 0.00 ☑ EV −1.64

Remove ghosts control

The other notable feature of Photoshop's Merge to HDR Pro tool is the excellent Remove ghosts control. When selecting the Remove ghosts check box, Photoshop will analyze the images and automatically search for any moving objects such as people, cars, or foliage, by comparing frames. If it detects moving objects, the program will automatically identify the image with the best tonal value and use the objects from that frame, removing them from all the other frames. If there is movement in very light or dark areas, you can then manually select a more appropriate frame. In the test image shown here, Photoshop had no problem deghosting the figures, leaving no halos or artifacts.

The benefits of Photoshop

Although Photoshop may not be as versatile as some dedicated HDR software (particularly if it's hyper-real images you want to create), it does have one major advantage over the other options we will be discussing: Raw processing. For optimum HDR results, you should always work with Raw files rather than TIFFs or JPEGs, as this will keep as much data in your HDR image as possible. As we saw earlier, while other programs let you open a range of Raw files, they do not necessarily allow you to edit them, and if they do, it is often in a limited way. With Photoshop, you can make a variety of alterations using Adobe Camera Raw (ACR), before running the Merge to HDR Pro command. For example, you can remove spots or blemishes, change the white balance, clarity/sharpness, or color saturation, apply noise reduction, and address any issues with lens distortion.

Synchronize

Furthermore, Photoshop also boasts a helpful Synchronize feature. This allows you to address the type of issues identified above on an entire sequence of images simultaneously. To do this you first need to open the full sequence of images in Camera Raw. This will bring up the ACR dialog with your sequence of images

arranged down the left hand side (1). If you want to make a change to the entire sequence, select one of the images (it's often easier to preview the changes you're going to make if you select the metered exposure). Then, click Select All at the top-left of the dialog. From now on any changes you make to the image you initially selected in ACR will be applied to all of the images in the sequence (2). This not only saves time (as, for example, you only need to fix dust spots on one image and they will be removed from the entire sequence), but it also ensures that other fixes, such as lens distortion, are applied consistently across the sequence.

Having made the changes, you can click the Open Images button, and then use the Add Open Files option after initiating the Merge to HDR Pro command, or click the Done button. If you choose the latter option the changes you specified within ACR will be applied whenever you choose to combine the images.

The Synchronize feature is also available in Lightroom. In the Develop mode, highlight the sequence of images you want to synchronize in the filmstrip at the bottom of the workspace, then click the Sync button at the bottom right corner of the screen (3). Any changes you make to one image will automatically be made to all the other selected images.

1

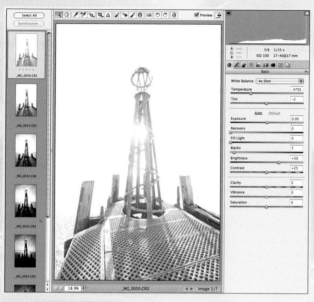

2

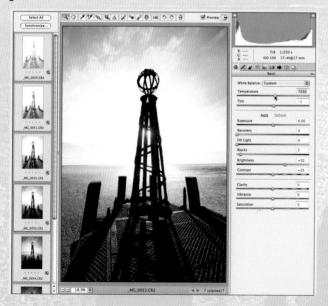

3

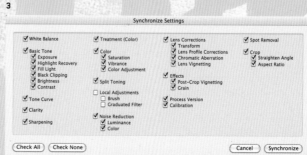

This HDR image was
tone mapped using
Photomatix Pro's

Details Enhancer
to produce a
hyper-real result.

Photomatix Pro

Photomatix Pro was one of the earliest HDR programs, and thanks to continued development it remains one of the most popular. Initially criticized for a complex-looking and difficult-to-use interface, later versions are much more user friendly, and now that it ships as a plug-in for both Aperture and Lightroom, it is an efficient option for your HDR workflow.

Photomatix features two ways of merging a series of exposures to create a single LDR image—Exposure Fusion and Tone Mapping. Exposure Fusion, however, doesn't rely on tone mapping; instead, put simply, it takes the highlights and shadows of a number of exposures and "fuses" them together to give the optimum result. Good, realistic results can be obtained, but it is not true HDR so I will not cover it in detail here. The Tone Mapping process, on the other hand, offers two options: the Tone Compressor and the Details Enhancer. The Tone Compressor option is a global operator, and is the simpler of the two. It provides noise- and halo-free images, but lacks the local adjustment of the Details Enhancer.

The Details Enhancer method is considerably more sophisticated, and can be used to produce both photorealistic and hyper-real images thanks to fifteen different sliders and controls that enable you to fine-tune the appearance of your tone mapped images. Because of its sophistication, adjusting an image using the Details Enhancer can often be a time-consuming process, but the results can be spectacular.

Generating a 32-bit HDR file

As with Photoshop, generating a 32-bit HDR file using Photomatix Pro is a straightforward process. As a standalone program, if you select Load Bracketed Photos... from the File menu (1) you will be presented with a dialog similar to the one in Photoshop (2). Just browse to your source files, or drag and drop them onto the dialog, after which you can click the OK button. Once the images are loaded you will be presented with another dialog (3).

At this stage you have a variety of decisions to make. The first relates to aligning the source images, and even if you have shot your bracketed sequence on a tripod it's a good idea to leave this selected, not least because even minor vibrations can misalign your images. You have two alignment choices—"By correcting horizontal and vertical shifts" and "By matching features." I use the second option as it's usually more accurate. Check the Crop Aligned Images box to remove any surplus detail at the edges of the frame.

Next, if there's any chance that the sequence contains moving elements select Reduce ghosting artifacts. We'll look at this in more detail over the page. Finally, there are the other pre-processing options that were discussed on pages 40–41. If you haven't pre-processed the images in a Raw editor, consider using the Reduce noise and Reduce chromatic aberrations options. You can also adjust the white balance of the generated HDR by using one of a number of presets, or by entering a custom value. Finally, you can also change the "color primaries" to reflect your destination color space.

Photomatix Pro as a plug-in

Photomatix Pro is available as a plug-in for Aperture or Lightroom as well as a standalone program. To generate the HDR file from Lightroom, for example, select the images to be used in either the Library or Develop screens, then under the File menu, select *Export with Preset>Photomatx Pro* (1). As before you will be presented with an options dialog box (2), which although similar to the one shown earlier, has slightly different options. There's no noise reduction slider, for example, nor are there any options to adjust the white balance. However, these are easily performed in Lightroom, which will take on board any amendments to the Raw files before exporting them. I recommend you select 16-bit TIFFs as the Output Format, as this retains as much image data as possible for any post-production work. Once you've made your selections, then press Export to merge the files.

1
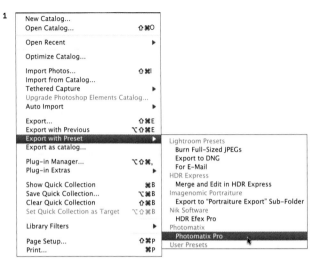

2
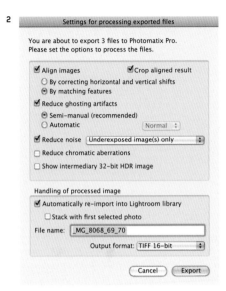

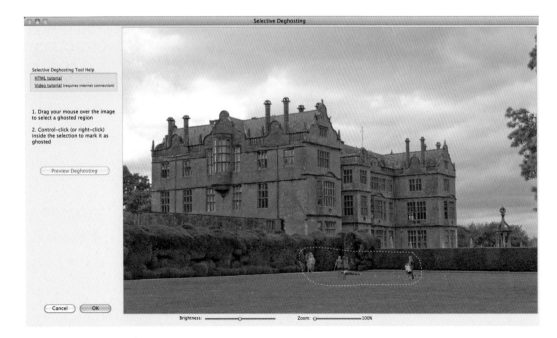

Deghosting with Photomatix

The recommended deghosting option in Photomatix Pro is the semi-manual option found under the Reduce ghosting artifacts' check box. In this mode, Photomatix provides a preview part way through the creation of the HDR image in which you highlight areas of ghosting by making a selection with the cursor. There's a Preview Deghosting button that provides a preview of how the image will look after the deghosting option has been run. If you're happy with the result, right-click inside the selection and press OK.

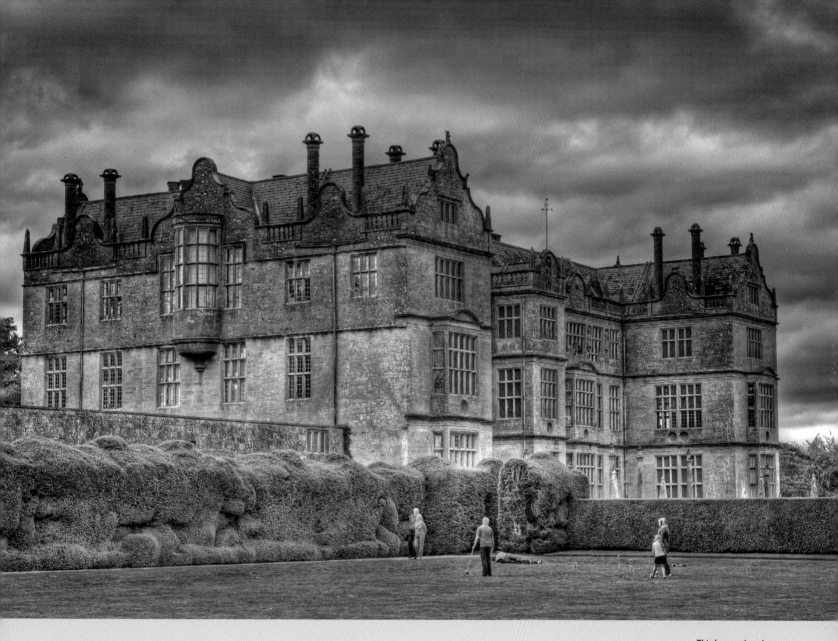

Photomatix Pro preview window

Once the files have been merged into the 32-bit HDR file, Photomatix Pro displays an attractive workspace featuring a large image preview, and comprehensive control panels, with a whole host of sliders and controls, which we'll look at in more detail in the next chapter.

Compared with Photoshop, Photomatix Pro is much faster at converting a bracketed sequence of images into an HDR image. If you have a powerful computer, this may not be an especially important factor, but for less powerful machines the difference in processing times can be significant.

This low contrast scene was enhanced using Photomatix Pro's tone mapping tools. Notice how the program's deghosting process has successfully rendered the moving figures.

HDR Express

Developed by US-based Unified Color Technologies, HDR Express is one of the more recent HDR programs. It follows the company's other HDR package, HDR Expose, and is targeted at those with less experience of HDR imaging. The user interface is deliberately simple, with fewer slider controls compared with other HDR programs such as Photomatix Pro and HDR Efex Pro, and many of the processes are automated. However, HDR Express shouldn't be considered as an amateur-only package: the results are generally on a par with the other HDR software discussed here, and it features one or two unique features, such as the dynamic range animation that help beginners in particular to engage with the process of creating HDR images. The software can be launched as a standalone program or as a third-party plug-in for both Aperture and Lightroom.

Generating a 32-bit HDR image

When using HDR Express as a standalone application to create a 32-bit HDR image, either go to *File>Merge to HDR...* (1) or click the *Create/Merge a new HDR Image...* box on the opening screen (2). This will take you to the Merge to HDR screen (3). Click the "+" symbol to bring up the browser window, similar to the one found Photomatix Pro or Photoshop's Merge to HDR Pro command, from where you can select your images (4). Alternatively, you can simply drag your images onto the application window to launch the program. HDR Express can read TIFF and JPEG files, along with all the most common camera manufacturers' proprietary Raw file formats. However, when you select a sequence of Raw files in this way, any amendments you have made in a Raw editor, such as Lightroom, will not be read. HDR Express will not recognize any XMP sidecar files, so these changes will not be incorporated during the creation of the 32-bit HDR image.

2

1

Open...	⌘O
Save	⌘S
Save As...	⇧⌘S
Close	⌘W
Merge to HDR... H	

3

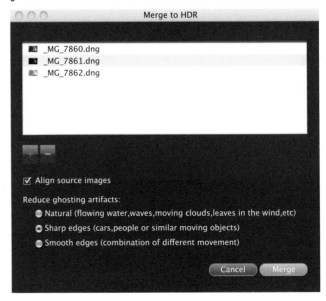

4

5

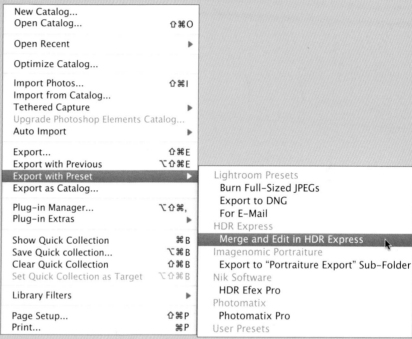

Merge to HDR

Once you've located and added all the files there are two simple options. The first is to choose whether or not you want the software to align the source images. If you're 100 percent certain that your frames align exactly, there's no need to check the Align source images box, and the merging process will run quicker. However, I would suggest in almost all cases, you'll get a better result if you keep this box checked. Next, decide on the most appropriate deghosting option for your particular sequence. There are three to choose from. We'll look later at HDR Express' deghosting performance. Now, having selected the source files and the deghosting option, click Merge.

Exporting from Lightroom

If you're using HDR Express as a plug-in for either Lightroom or Aperture, you can access the program directly from the Raw editor to speed up the workflow. To begin the merge operation in Lightroom, select the sequence of images in either the Library or Develop mode, and go to *File>Export with Preset>Merge and Edit in HDR Express* (5).

Because Lightroom converts the Raw files into 16-bit TIFF files as part of the export routine, any amendments made to the Raw files will be applied to the TIFFs before they are merged. Essentially, this allows you to perform any pre-processing that Lightroom permits.

Dynamic range animation

The first thing HDR Express does once it has finished merging the source files, and before you start the tone mapping process, is to automatically play a dynamic range animation. The image initially appears dark on your screen and gradually brightens. What the program is showing you in real time is the entire tonal range present in the 32-bit file, from the deepest shadows to the brightest highlights. You can replay the animation by clicking the arrow button below the histogram. As well as providing a visual representation of the tonal range of your image, the histogram feature can also be used as a highlight and shadow warning tool. Press "H" and the letter turns red, along with any highlights in the preview window that are burning out. Press "S" and the letter turns blue, as do any shadow regions, which are blocked in showing no detail. The Image range: reading provides you with an EV figure telling you how many stops there are between the lightest and darkest elements in the image.

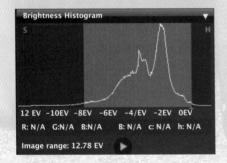

Brightness Histogram

S H

12 EV –10EV –8EV –6EV –4/EV –2EV 0EV

R: N/A G:N/A B:N/A B: N/A c: N/A h: N/A

Image range: 12.78 EV

Reduce ghosting artifacts:

- Natural (flowing water, waves, moving clouds, leaves in the wind, etc)
- Sharp edges (cars, people or similar moving objects)
- Smooth edges (combination of different movement)

Deghosting with HDR Express

The three deghosting options available with HDR Express are Natural, Sharp edges, and Smooth edges. A brief description after each option indicates in which type of ghosting situation you should select it. In this sample, HDR Express' deghosting process has been less successful compared with Photomatix and Photoshop at rendering this group of moving people. There are ghosting artifacts and dark outlines of their other positions are visible.

HDR Express is quick and very simple to use—and with the right source files can produce excellent results. However, its lack of control could be restricting for those more familiar with HDR.

HDR Efex Pro

Nik Software has been developing digital-imaging software since 1995, and is widely recognized by professionals and amateurs alike for producing powerful, yet user-friendly, digital photographic filters and plug-ins. The list of software includes Silver Efex Pro, Color Efex Pro, and Sharpener Pro, and to these has been added HDR Efex Pro.

As with its other software, HDR Efex Pro features Nik's powerful and versatile U Point technology, which, via a system of control points adds powerful, localized editing possibilities, and is a distinct positive of this HDR software. Also, as with Nik's other products, the user interface is attractively laid out and intuitive, making HDR Efex Pro an enjoyable program to use. The level of control is on a par with Photomatix Pro, and like Photomatix, HDR Efex Pro provides a greater range of styles and effects than Photoshop's Merge to HDR Pro command.

Generating a 32-bit HDR image

As with most of the other packages covered in this section, HDR Efex Pro comes either as a standalone program or a plug-in for Lightroom and Aperture.

When using HDR Efex Pro as a standalone program, there is only one way to begin the 32-bit HDR generation process: select Open Exposure Series from the File menu and in the resulting browser window navigate to the sequence of images (1). You'll notice straightaway that unlike most of the other HDR software examples, HDR Efex Pro will not read any Raw formats, working only with TIFFs and JPEGs. Nor can you drop a selection of images, even if they are TIFFs or JPEGs, onto the application icon to start the program running.

If you're using HDR Efex Pro as a plug-in, with Lightroom for example, select the sequences of images to be merged, and under the File menu go to *Export with Presets>HDR Efex Pro* (2). When exporting from Lightroom or Aperture, the Raw files are automatically converted to TIFFs, and, as with HDR Express, will export with any pre-processing amendments that you may have made.

HELP SETTINGS

Deghosting with HDR Efex Pro

Clicking on the Settings button at the bottom of the tone map preset styles panel brings up the Settings dialog, from where you can adjust interface controls, choose update and output settings (1) (again I recommend 16-bit TIFFs), select with which source image the tone mapped image is stacked in Lightroom or Aperture when it's reimported, along with alignment and deghosting options (2). Switch Alignment to On unless you've already aligned the images in another software program, or you're certain the source images aligned perfectly at the time of capture.

HDR Efex Pro features two Ghost Reduction methods; Global and Adaptive (3). Use Global in cases when relatively large moving objects, such as people and cars, are duplicated in the merged HDR image. This algorithm will attempt to remove all duplicated objects from all but one source image, so that only one example of each appears in the scene. The Adaptive setting should be used for small movements, such as grass and leaves, or ocean ripples. If using one of the Ghost Reduction methods, try with Strength set to Medium first. If this doesn't provide a satisfactory result, increase the setting to High. If there are still unwanted artifacts in the preview, try the Low setting or the alternative Ghost Removal method. There are occasions when HDR Efex Pro cannot entirely remove moving objects. The image here, for example, shows that HDR Efex Pro copes better than HDR Express in our sample, but not as well as Photoshop or Photomatix Pro. There are dark and light halos visible around the moving figures.

1

Settings

▶ INTERFACE SETTINGS
▶ ALIGNMENT & GHOST REDUCTION
▶ SOFTWARE UPDATE SETTINGS
▼ IMAGE OUTPUT SETTINGS

Image Output Format: ✓ JPG
JPEG Quality TIFF 8
 TIFF 16

▶ STACKING

2

Settings

▶ INTERFACE SETTINGS
▼ ALIGNMENT & GHOST REDUCTION

Alignment: On
Ghost Reduction Method: Global
Ghost Reduction Strength: High

▶ SOFTWARE UPDATE SETTINGS
▶ IMAGE OUTPUT SETTINGS
▶ STACKING

3

Alignment and Ghost Reduction

Alignment and Ghost Reduction Controls

☑ Alignment:

☑ Ghost Reduction Method: Adaptive

 Ghost Reduction Strength: Low

An alternative way of accessing the Alignment and Ghost Reduction controls, and one that's more convenient if you've already created the HDR image is to click on the Alignment & Ghost Reduction button at the top of the preview window. This brings up the same options as those in the Settings panel. If one deghosting method isn't successful you can set an alternative here and re-run it.

HDR Efex Pro Control Points

Control Points in HDR Efex Pro utilize Nik's U Point technology, which will be familiar to you if you have used other Nik software.

Control Points allow you to make localized adjustments to your image, and use a highly effective and intuitive interface. To begin, click on the Add Control Point button in the Selective Adjustments section of the main control panel (1). Using the cursor, click on a point in the image that you want to adjust. The Control Point will appear as the central point alongside and under which there are four sliders (2). Place the cursor on the top slider and a selection ring will appear from the central point. Use the slider to adjust the diameter of the selection circle until you've selected the area you want to adjust (3). The selection is feathered so that any amendments blend with the surrounding area. Click on the next slider and instantly it becomes an Exposure control. Move the slider right to increase exposure or left to reduce it. An EV value helps you to judge the level of adjustment (4). The next slider is Contrast (5), and the one beneath that is Saturation (6).

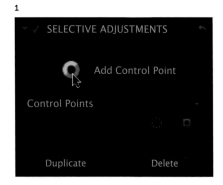

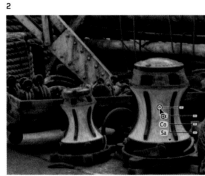

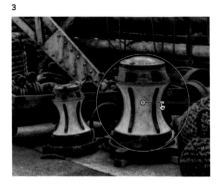

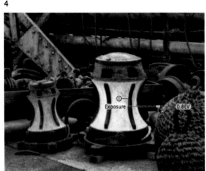

7

8

9

10

11

12

These are the most common adjustments and correspond to the first three sliders in the main control panel. However, click on the small black arrow at the bottom of the control point and an additional five sliders appear (7). Again, these correspond to the next five sliders in the control panel—Structure, Blacks, Whites, Warmth, and Method Strength. Most of these are self-explanatory, but we'll be covering them all in more detail in the next chapter. Return to the main panel and you'll see the list of Control Points you've added to the image. The percentage value refers to the percentage of the entire image covered by the point. Next to the coverage percentage value is the Show/hide selection of Control Point box (8). Toggle this on and off and in the main view all but the selected area is blacked out (9). Click the Duplicate button to create add another Control Point (10). This will appear next to the original point on the main image view, and from there you can click and drag it to a new position. It will have the same values as the original point (11). Use the Show/hide effect of the Control Point box to turn each of the points on and off (12).

When you've finished editing the tone map preview, click Save at the bottom of the control panel to apply the adjustments. If you're using HDR Efex Pro as a plug-in, the file is automatically saved in the same folder as the source files.

Oloneo PhotoEngine

Oloneo PhotoEngine was released in the middle of 2011, and is the most recent HDR program covered here. As of 2011 the software was only available for Windows users, but with "virtual PC" software it can also be run on a Mac.

Interestingly, PhotoEngine is more than a dedicated HDR program, and comprises three separate modules; HDR ToneMap, HDR ReLight, and HDR DeNoise, as well as being a Raw processor. Briefly, HDR ReLight allows for editing of different light sources in an image. To work, up to six source images (naturally of the same scene but lit differently) must share the same exposure settings (shutter speed and aperture). HDR DeNoise requires the same stipulation to work.

Naturally, however, what interests us most is the HDR ToneMap module. Oloneo has included four tone mapping engines in the software; Auto, Local, Advanced, and Global, providing a variety of algorithms to select from to get your desired result. Other impressive statistics include forty tone mapping style presets, ultra-wide gamut, a natural HDR processing mode, edge sharpening, and halo control. Although in terms of numbers of sliders the level of control is not on a par with Photomatix or Efex Pro, PhotoEngine is a powerful HDR tool—it's user friendly and creates high-quality results.

Generating a 32-bit HDR image

Once you've launched PhotoEngine, you're immediately presented with the main window from which you perform the entire HDR and tone mapping process. Click the box next to the Browsing pull-down menu (1) to bring up the browser window (2). From here you can select the folder containing your source images. Once you've selected the folder, the images will be displayed as thumbnails in the main window (3). PhotoEngine can read all common Raw formats, as well as TIFF and JPEG files.

As with Photomatix Pro and HDR Express, if you're navigating in this way to Raw files that have been pre-processed in some way, PhotoEngine cannot read the XMP sidecar files and so the pre-processed adjustments will not be applied.

1

2

3

4

Project Image Selection

Show Exposure Compensation only

Image	Shutter Speed	F-Number	ISO	Exposure Comp.
	1/1000	8.00	100	-2.00
	1/60	8.00	100	-2.00
	1/250	8.00	100	0.00

Add Remove Clear

5

HDR ToneMap [?]

Ready to create HDR ToneMap Project!

Auto Align Ghost Removal: method 2 ▼

Create HDR ToneMap Project

Select the source files you wish to use and click the Add button in the Project Image Selection panel (4). A thumbnail of the images will be displayed, along with exposure information for each shot.

Having selected your images you're ready to start the HDR/tone mapping process. Go to the HDR ToneMap box (5). If you used a tripod when shooting your source sequence don't check Auto Align. Auto Align runs additional processing that slightly degrades the image.

Deghosting with PhotoEngine

If your image has moving objects select one of the two ghost removal methods. Oloneo claims the two algorithms are very different, and that you should try method two first. If you're not happy with the results, try method one. Oloneo also suggests that if you're capturing a scene with a lot of movement, shooting and processing more than one sequence of the same scene can provide better results as the software has more data with which to create a ghost-free image.

In this example (left), PhotoEngine has performed extremely well, leaving no ghosting artifacts or halos. It's as successful as Photoshop and Photomatix Pro in this respect.

Once you've selected the deghosting option click Create HDR ToneMap Project to generate the 32-bit HDR image. Photo-Engine processes the source files quite quickly. It's as fast as HDR Express, and certainly faster than Photoshop.

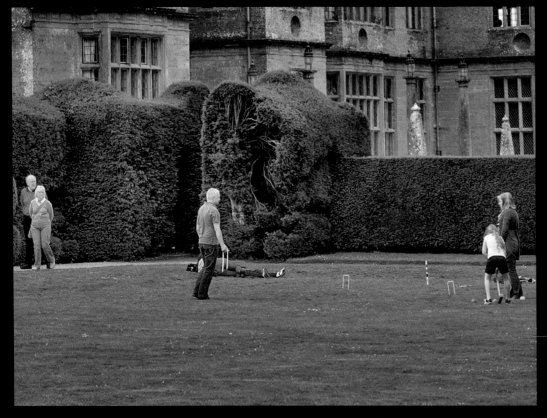

Which program should you use?

At this stage, it's worth pointing out that we have only just begun our discussion on the five programs covered in the book. Processing the bracketed sequence into a single 32-bit HDR image is only the first stage; we've yet to use the various tone mapping processes offered by the five programs to create a 16-bit or 8-bit LDR image that we can view on screen or print out. So making any definitive judgement over the software at this stage would be premature. Having said that, we can validly discuss how each performs at this initial merging stage.

Photoshop Merge to HDR Pro

Photoshop's Merge to HDR Pro command has clearly improved considerably since its precursor. Leaving aside the tone mapping controls that we will be looking at in the next chapter, what impresses most about this latest HDR option from Adobe is its deghosting ability. It's automated and extremely accurate, creating no ghosting artifacts or halos around the moving objects. Along with Oloneo's PhotoEngine and Photomatix Pro, it performed equal best with the sample image.

Another good reason for using Adobe's option is that it's a component of Photoshop. This has two major benefits. First, using Merge to HDR Pro negates the need to launch, export to, and import from another program—so smoothing the HDR workflow. Secondly, as part of Photoshop, Merge to HDR Pro works seamlessly with ACR. Unlike the other HDR programs, Merge to HDR Pro can incorporate any changes you make to the sequence of Raw files through its ability to read the XMP

sidecar files that provide the instructions for the amendments. The result is that Merge to HDR Pro gets to use the extra data found in Raw files compared with TIFFs and JPEGs, while also having the ability to incorporate any pre-processing amendments, such as fixing lens distortion, chromatic aberration, or noise reduction, for example.

One drawback to Photoshop's Merge to HDR Pro command is the time it takes to merge the source files. If your computer has a relatively old specification, you may find yourself waiting a significant number of minutes for the merge to complete. If you were undertaking a lot of HDR work, this would definitely become a drawback.

Photomatix Pro

Photomatix Pro was one of the first dedicated HDR programs, and for this reason was, for some years, the most widely used. Since the launch of rival programs, Photomatix Pro has lost some of its dominance, but it remains a capable program, and thanks to regular updates to its user interface and processing algorithms, has remained very popular.

Photomatix Pro has a good, semi-automated deghosting routine that, like Photoshop and PhotoEngine, produces ghost- and halo-free results. Available as a third-party plug-in for Lightroom and Aperture (as well as a standalone application), Photomatix Pro offers a smooth workflow, particularly if you've undertaken any pre-processing to the source sequence, as both Lightroom and Aperture will export the amended Raw files into Photomatix as JPEGs or TIFFs (with the amendments in place). It's worth remembering, however, that if

you're using Photomatix as a standalone program, the software can read most types of Raw file, but it won't incorporate any changes made to those files when merging to create the HDR image. Unlike most of the other programs it does offer some level of Raw pre-processing in the form of chromatic aberration correction and noise reduction.

HDR Express

HDR Express is a relatively new HDR program, aimed at those with little experience of HDR imaging. It's fast and easy to use and, like Photomatix Pro, is either a standalone program or third-party plug-in.

In our sample test, it has less successful deghosting algorithms, however, as Photoshop, Photomatix, or PhotoEngine.

HDR Efex Pro

HDR Efex Pro is a powerful HDR program that offers excellent levels of control whether it is used as a plug-in or a standalone application. However, it cannot read any Raw file types, so all Raw image sequences need to be converted to TIFF or JPEG files before they can be combined. Also a third-party plug-in and standalone program, HDR Efex Pro differs from the other programs already mentioned in that it cannot read any Raw file types. Therefore if you're using it as a standalone program you'll have to save the sequence of Raw files as TIFFs or JPEGs before merging.

HDR Efex Pro is a versatile option, which thanks to its powerful U Point technology, provides the user with the means of easily making effective localized adjustments.

In terms of its deghosting abilities, HDR Efex Pro seems less effective compared with Photoshop, Photomatix, and PhotoEngine, although an improvement on HDR Express.

Oloneo PhotoEngine

The most recent of all the programs under discussion, PhotoEngine is also the only program that is not compatible with Mac OS (although this may well change).

Again available as a standalone program or third-party plug-in, PhotoEngine offers a good level of control and clean tone mapped results. Its deghosting algorithms are powerful and seem as good as Photoshop and Photomatix Pro.

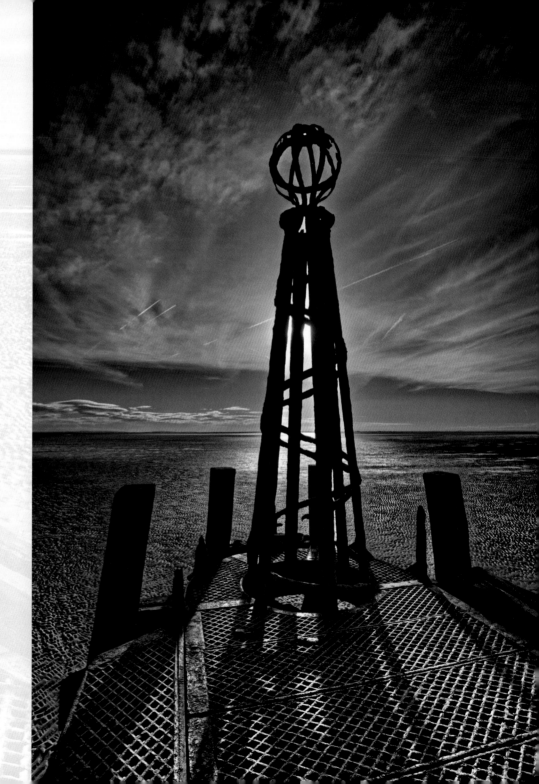

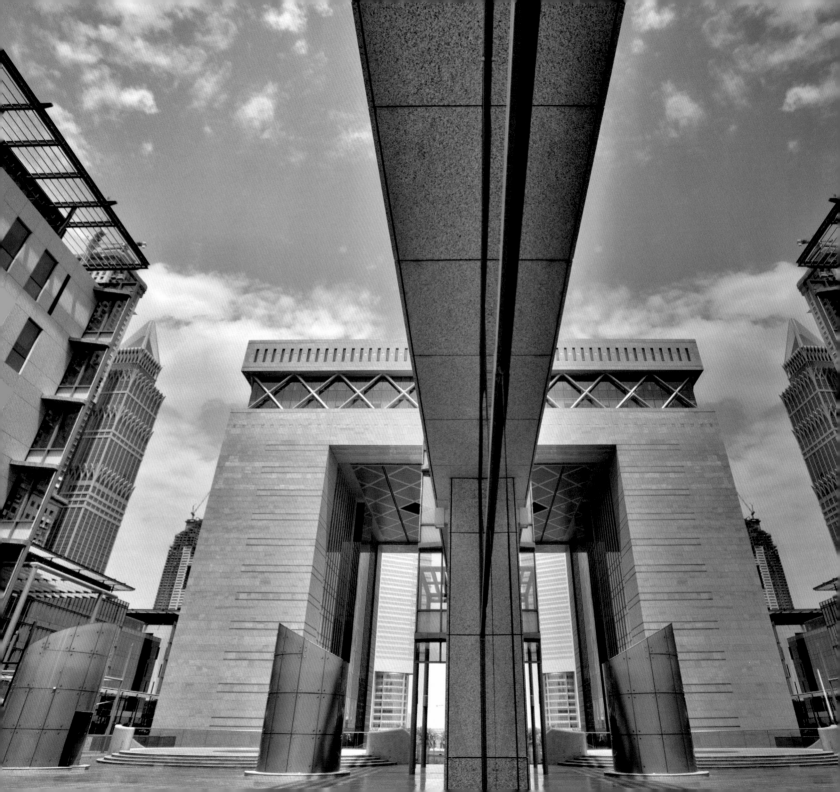

Chapter 4:
Creating Photorealistic HDR Images

Photorealism and HDR Photography

A single exposure

A tone mapped version
of the same subject

A more illustrative, or "hyper-real" tone mapped image.

So, on the one hand, we can consider HDR techniques as a method of producing a photorealistic representation of a scene, while on the other, we can view it as a technique that can be employed to generate a more surreal interpretation.

The key point here is that these radically different styles are generated using the exact same tools and procedures—they are just applied in different ways. In both cases, you need to shoot a bracketed sequence of exposures and generate an HDR image, and in both cases you need to tone map the HDR image to produce an LDR version that can be printed and displayed. Therefore, the difference between the two styles is not a technical one, but simply a function of the way you tone map your HDR image. One choice of settings will produce a more photorealistic result, while more extreme settings will produce a hyper-real result, with myriad possibilities in between.

In this chapter we will concentrate on producing photorealistic images, while the following chapter will focus on creating hyper-real HDR images. But it is important that these should be seen as extreme positions on the same continuum, and not mutually exclusive alternatives. You can aim to produce an image using either style, or a final picture that falls somewhere between the two. By the time you have worked through both chapters you will have a sufficiently detailed understanding of how to control the tone mapping process to suit your own creative and esthetic aims.

Photoshop's HDR Options

The HDR preview image

Previewing the darker tones

Previewing the lighter tones

When you create an HDR image using Photoshop's Merge to HDR Pro command, the preview of the merged result is displayed as a 16-bit image using the default Local Adaptation values. If you want to save the merged image as a 32-bit HDR file, select 32-bit in the Mode pull-down menu. The preview image contains a range of clipped highlights and shadows. This is because a typical computer monitor is an LDR (low dynamic range) device. In this example, the shadows appear to be clipped most notably in the building at the right of the image, while the cloudier elements of the sky in the background are grossly overexposed. At this stage, if you want to preview

the range of tones contained within the original HDR image you can adjust the slider beneath the histogram. Note that dragging the slider to the right darkens the image, allowing you to preview the lighter tones, while dragging it to the left allows you to examine the darker areas. In both examples, you can see that the initial HDR contains a full range of tones, with no clipping at either extreme. Note that dragging the slider only adjusts the preview and doesn't affect any of the HDR image data. You can save the HDR file in a variety of formats, including the two most widely compatible formats (EXR and Radiance HDR) if you want to use alternative HDR software.

If you want to apply tone mapping adjustments in Photoshop, return to the Mode pull-down menu and select either 16-bit or 8-bit. If you intend to do further post-production on your tone mapped image later, convert to 16-bit as this will provide an LDR image with considerably more data to work with.

Having chosen your output bit depth you then have the option of selecting one of four conversion methods; the default Local Adaptation, Equalize Histogram, Exposure and Gamma, and Highlight Compression. Over the coming pages we will look at the Local Adaptation method in more detail, but first we will take a quick look at the other three methods.

Highlight Compression

The Highlight Compression method is one of the simplest algorithms you can apply to an HDR image. It works by compressing the highlight details in the original 32-bit image to fit within the luminance range of a 16-bit or 8-bit file. This is an entirely automatic process, but it tends to produce a rather dark final image. As you can see from the example image, highlight detail is visible, but the shadow areas are still very dark.

Converted using the Highlight Compression method

Equalize Histogram

Photoshop's Equalize Histogram conversion method is also an automatic process, which works by compressing the entire dynamic range of the original HDR image, while attempting to retain contrast within the image in the process. On first inspection it appears to produce a slightly better result than Highlight Compression, creating overall brighter images. However, as you can see in this example, the shadows are still too dark, and the highlight detail of the sky appears washed out, which defeats the purpose of shooting a range of exposures to capture the full dynamic range of the scene.

Converted using the Equalize Histogram method

Exposure and Gamma

Unlike the Highlight Compression and
Equalize Histogram tone mapping
options, Photoshop's Exposure and
Gamma method provides a certain
degree of manual control. This takes
the form of two sliders; Exposure and
Gamma. These allow you to adjust the
brightness and contrast of the image.
Use the Exposure slider to control
the brightness and the Gamma slider
to adjust contrast.

With only two sliders to adjust, trying
to achieve a tonally balanced image that
appears naturalistic is almost impossible
in most cases. Images converted using
the Exposure and Gamma method often
contain a variety of color casts, and
the tonal range is more restricted
than those produced using the Local
Adaptation method, as we shall see.

However, if you adjust the sliders until
you have an acceptable tonal range
(although poor contrast), save the image
as a 16-bit TIFF, and then fine-tune the
contrast in Photoshop using either a
Curves or Levels adjustment, you can
improve the image greatly.

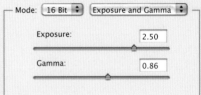

Exposure adjustment

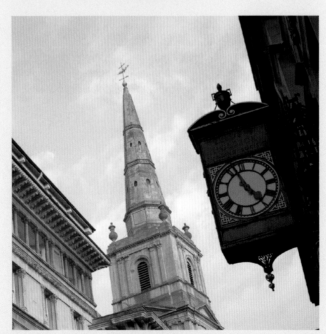

Curves adjustment

Local Adaptation

Local Adaptation (as its name implies) is a method of constructing an LDR image that attempts to create local contrast within different areas of an image. In practice, this means that different areas within the image will each have a reasonably high tonal range in their own right, so a sky will have a reasonably distributed tonal range, as will the shadow areas of the image, the highlight areas, and so on.

Once you have created (or opened) your HDR file and selected Local Adaptation as the tone mapping method, you're presented with a panel featuring nine control sliders arranged into three discreet sections; Edge Glow, Tone and Detail, and Color/Curve. This is significantly more than were available in Photoshop's previous Merge to HDR command, offering you greater control and flexibility.

At the top of the control panel is the Preset pull-down menu. There is a total of thirteen preset options, ranging from Photorealistic to Surrealistic, including four black-and-white options.

With this example image, the Default settings have worked reasonably well, but the shadows are still underexposed. The Photorealistic High Contrast setting has provided strong tones in the midrange areas, but the highlights are overexposed and the shadows are totally underexposed.

The presets clearly therefore won't provide a totally satisfactory result straightaway. They do, however, provide a good starting point.

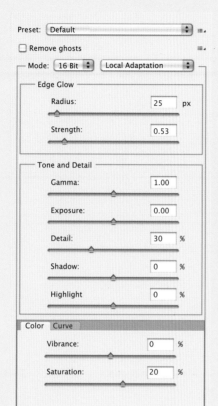

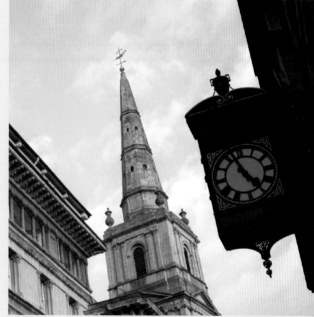

Default

Photorealistic High Contrast

Local Adaptation dialog

The purpose of some of the Local Adaptation sliders is obvious, but others are not quite as intuitive.

1

Edge Glow

The Edge Glow controls determine the size and number of local brightness regions. Radius sets the actual size of the local brightness regions, and Strength determines which pixels fall into which brightness region.

2

Tone and Detail

Many of the controls in the Tone and Detail setting will be familiar: Gamma sets contrast; Exposure controls brightness; Detail determines sharpness and texture; and the Shadow and Highlight sliders control brightness specifically in the shadow and highlight regions of the image.

3

Color

The two Color sliders work in slightly different ways. Saturation increases or deceases colors across the entire spectrum and can result in colors clipping, whereas Vibrance increases saturation in subtle colors and won't cause clipping.

4

Curve

The Curve, similar to the Curves adjustment found in Photoshop, allows you to adjust tones that are identified as points on a line. By default, moving one point on the curve will also adjust tones of a similar value. Click the Corner box, however, and your amendments are no longer equalized; this allows you to make more radical localized adjustments.

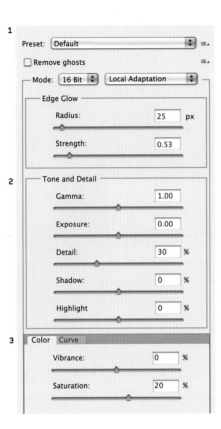

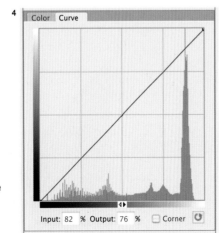

This image comprises three exposures that cover the entire tonal range of the scene.

EV-2

Metered exposure

EV+2

In this example, the tone mapping settings shown below have been coupled with a Curve adjustment to create a photorealistic result. You'll notice that I've not adjusted the Detail value at all. The effect of this slider is to increase sharpness, and it really comes into its own when creating hyper-realistic images, as we'll see in the next chapter.

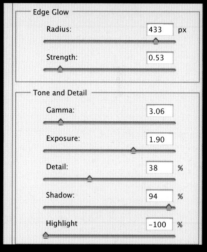

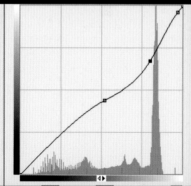

Curves require practice if you want to get the best from them. However, there are no hard and fast rules about how to use the Curve or how many control points you should use—it is simply about the esthetics of the image.

Photomatix Pro's Tone Compressor

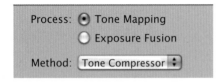

Photomatix Pro provides two ways of tone mapping an image—the Tone Compressor and the Details Enhancer. There is a third way of combining a sequence of bracketed images (Exposure Fusion), although this doesn't involve generating a 32-bit HDR image and is therefore not a true HDR technique.

Of the two tone mapping methods Tone Compressor is easier to use than the Details Enhancer, but it can be equally effective, especially if you are aiming to produce a photorealistic result. To illustrate this, I am using an HDR file generated in Photomatix Pro from a sequence of six images.

−2EV

−1EV

Metered exposure

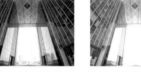

+1EV

+2EV

+3EV

As soon as your sequence of images have finished merging, you are presented with a preview window that shows how your image will appear after you have applied the tone mapping settings. It's worth noting that the preview in Photomatix Pro is never entirely accurate: to show the preview in "real time" it has to approximate the settings, whereas the actual tone mapping process is a processor-intensive task that has to apply a complex set of algorithms. Generally speaking, the differences between the two are not major.

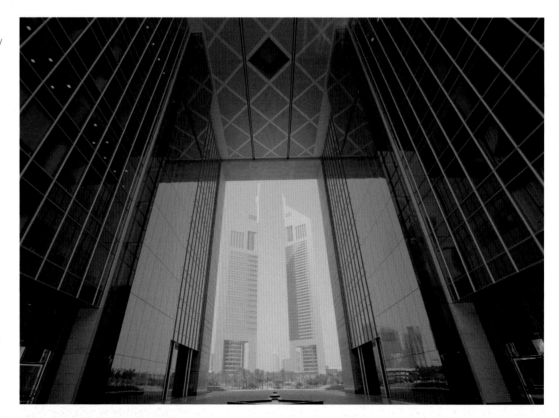

Photomatix Pro's default Tone Compressor settings produce an HDR image with plenty of detail in the shadow and highlight areas, but altering the various controls will make it even better.

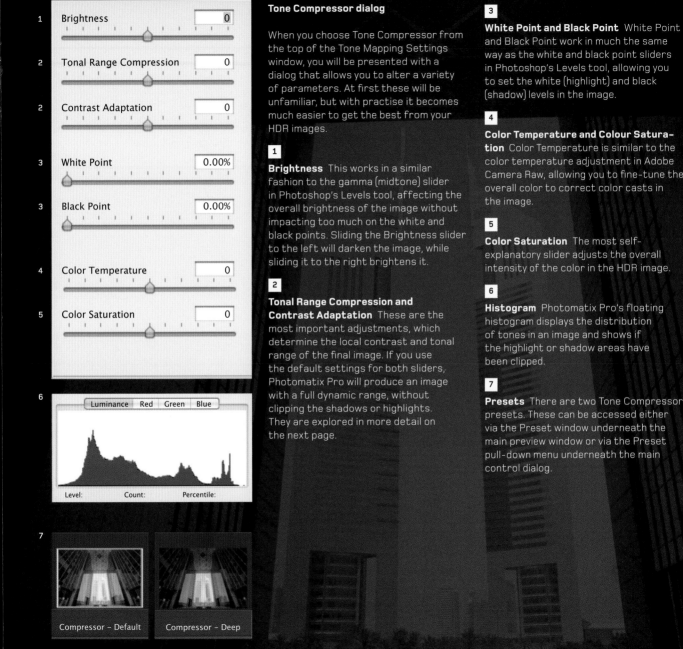

1 Brightness — 0

2 Tonal Range Compression — 0

2 Contrast Adaptation — 0

3 White Point — 0.00%

3 Black Point — 0.00%

4 Color Temperature — 0

5 Color Saturation — 0

6

Luminance | Red | Green | Blue

Level: Count: Percentile:

7

Compressor – Default Compressor – Deep

Tone Compressor dialog

When you choose Tone Compressor from the top of the Tone Mapping Settings window, you will be presented with a dialog that allows you to alter a variety of parameters. At first these will be unfamiliar, but with practise it becomes much easier to get the best from your HDR images.

1

Brightness This works in a similar fashion to the gamma (midtone) slider in Photoshop's Levels tool, affecting the overall brightness of the image without impacting too much on the white and black points. Sliding the Brightness slider to the left will darken the image, while sliding it to the right brightens it.

2

Tonal Range Compression and Contrast Adaptation These are the most important adjustments, which determine the local contrast and tonal range of the final image. If you use the default settings for both sliders, Photomatix Pro will produce an image with a full dynamic range, without clipping the shadows or highlights. They are explored in more detail on the next page.

3

White Point and Black Point White Point and Black Point work in much the same way as the white and black point sliders in Photoshop's Levels tool, allowing you to set the white (highlight) and black (shadow) levels in the image.

4

Color Temperature and Colour Saturation Color Temperature is similar to the color temperature adjustment in Adobe Camera Raw, allowing you to fine-tune the overall color to correct color casts in the image.

5

Color Saturation The most self-explanatory slider adjusts the overall intensity of the color in the HDR image.

6

Histogram Photomatix Pro's floating histogram displays the distribution of tones in an image and shows if the highlight or shadow areas have been clipped.

7

Presets There are two Tone Compressor presets. These can be accessed either via the Preset window underneath the main preview window or via the Preset pull-down menu underneath the main control dialog.

Tonal Range Compression

According to the Photomatix Pro manual, Tonal Range Compression "controls the compression of the tonal range. Move the slider to the right to shift both shadows and highlights toward the midtones in the tone mapped image."

In practice, decreasing the value (moving the slider to the left) will almost always lead to the image containing a large amount of clipped shadows.

If you drag the slider in the opposite direction, to increase the value, both the shadow and highlight areas will become brighter, although the change is most noticeable in the shadow areas.

Contrast Adaptation

Photomatix Pro describes Contrast Adaptation as an option that "adjusts the influence of the average brightness in relation to the intensity of the processed pixel. Move the slider to the right to create more pronounced colors. Move the slider to the left to create a more 'natural' look."

An alternative way to describe these effects is with reference to tone. If you drag the slider to the left you decrease the value, and your histogram is extended. Dark areas become darker, and light areas become lighter.

Conversely, if you shift the slider to the right, you increase the amount of Contrast Adaptation, which has the effect of compressing the histogram and creating a much flatter (lower contrast) image.

At this stage it's worth mentioning that every set of bracketed exposures you shoot will be different, and there are no "absolutes" when it comes to the optimum settings. Each HDR image you create will require you to spend some time trying out alternative options. Having determined the settings that you think work best for your particular image, click the Process button to generate your LDR image. Once the process is complete you simply need to save the file (*File>Save As*) as either a 16-bit or 8-bit TIFF or JPEG file. If you intend to do some subsequent work in Photoshop, save your image as a 16-bit TIFF to get the highest quality image, or, if you intend to email the image, or post it online, save it as an 8-bit JPEG file.

Tonal Rage Compression: –10

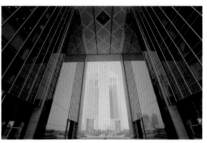

Tonal Rage Compression: +10

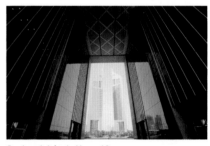

Contrast Adaptation: –10

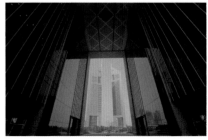

Contrast Adaptation: +10

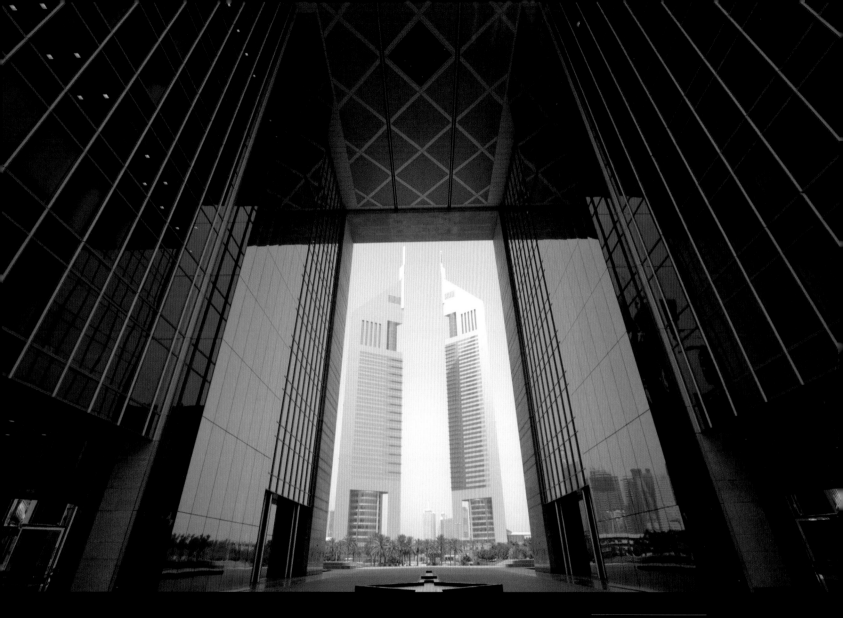

Tone Compressor settings

Brightness: –1
Tonal Range Compression: 1
Contrast Adaptation: 10
White Point: 2.90%
Black Point: 0.00%
Color Temperature: –2
Color Saturation: –4

Photomatix Pro's Exposure Fusion

Process: ○ Tone Mapping
 ◉ Exposure Fusion

Method: ▣ H & S – Adjust ⬦

As I mentioned earlier, Exposure Fusion is not strictly a form of HDR imaging as no 32-bit HDR files is created. Nor does any tone mapping take place to render the 32-bit file a LDR image. However, it's relevant here as the process does involve using a sequence of bracketed exposures to create a single image displaying the full range of tones.

The concept behind Exposure Fusion is simple: it takes the accurately exposed highlights, midtones, and shadows from the various images of the bracketed sequence and blends or fuses them together to form a single LDR image. There's nothing particularly new about blending a sequence of exposures—people have been doing it manually in Photoshop for years—however Photomatix's Exposure Fusion method is much quicker and provides real-time control over which tones you blend from which exposures.

Exposure Fusion is a less processor-intensive method compared with tone mapping and therefore much quicker. Additionally, whereas tone mapping tends to introduce noise, Exposure Fusion does not. Excellent photorealistic results are possible with Exposure Fusion and for this type of image it's certainly worth trying, but if you're looking for the more surreal HDR look you'll have to turn to tone mapping. Exposure Fusion also does not offer any deghosting options, so images with moving objects will exhibit ghosting artifacts.

There are five Exposure Fusion methods to choose from in Photomatix Pro; H & S (Highlights & Shadows) - Adjust (the default option), Average, H & S - Auto, H & S - 2 images, and H & S - Intensive. The Adjust method provides the greatest control, and we'll look at this in more detail later. Average offers no level of control, instead it automatically merges the images together using an average value for each pixel based on all the exposures. H & S - 2 images allows you to select whichever two images you want from the sequence and creates an average image from the two selected.

Finally H & S - Intensive, although it offers three sliders—Strength, Color Saturation, and Radius—results in dramatic localized tones (often with halos) and is difficult to control.

✓	H & S – Adjust
	Average
	H & S – Auto
	H & S – 2 images
	H & S – Intensive

Photomatix Pro's default Exposure Fusion settings produce a very clean, tonally balanced, photorealistic image.

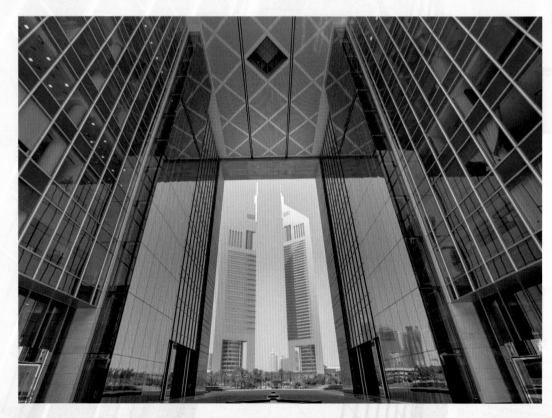

☐ 360° image

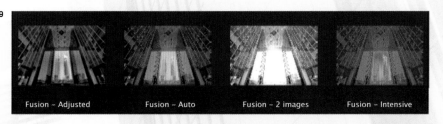

Fusion – Adjusted Fusion – Auto Fusion – 2 images Fusion – Intensive

Exposure Fusion dialog

The Exposure Fusion dialog has some of the same controls as the Tone Compressor dialog, but with one or two major differences.

1 **Accentuation** This affects localized contrast in the image. The effect is subtle, and so cannot cause any unwanted artifacts. Generally, if you move the slider to the left, the image becomes slightly darker, whereas moving the slider to the right brightens the image slightly. On both occasions there is a slight shift of contrast.

2 **Blending Point** Adjusts the emphasis given to either the underexposed images or the overexposed images. Moving the slider to the left gives more weight to the underexposed images and so darkens the preview. Moving the slider to the right gives more emphasis to the overexposed images and so brightens the preview.

3 **Shadows** The Shadows slider allows you to adjust the brightness of shadow regions independently of the highlights and midtones. Moving the slider to the right intensifies or darkens shadows.

4 **Color Saturation** Color Saturation ranges from grayscale to slightly oversaturated. The default setting is 0. Move the slider to the left to -10 for a desaturated image or to the right to +10 for a brightly colored image.

5 **White Clip** Sets the point at which highlights are clipped. Move the slider to the right to increase the range of highlights that lose detail. This has the effect of increasing contrast.

6 **Black Clip** Sets the point at which shadows are clipped. Move the slider to the right to increase the range of shadows that lose detail. This also has the effect of increasing contrast.

7 **Midtones adjustments** Controls the brightness of the midtones. Move the slider to the left to darken the midtones, and to the right to brighten midtones.

8 **Histogram** Exposure Fusion's histogram shows the distribution of tones in an image and shows if the highlight or shadow areas have been clipped.

9 **Presets** There are five Exposure Fusion presets. These can be accessed either via the Preset window underneath the main preview window or via the Preset pull-down menu underneath the main control dialog.

HDR Express

In the previous chapter we looked at producing an HDR image using HDR Express, and in this section we see how you can use this program to tone map your images, concentrating on producing photorealistic images.

Aimed at those with less experience of HDR imaging, HDR Express is among the most straightforward of all the HDR programs. Much of the process is automated, making HDR Express quick and intuitive to use, yet it still provides an adequate level of control should you want to make manual adjustments. In most cases going from the merged sequence to a tone mapped image takes a matter of one or two minutes.

The seven-shot sequence I am using as a starting point was shot from the Madinat Jumeirah resort in Dubai, with the Burj Al-Arab in the background. The images were recorded with a 1EV spacing, but as you can see, the dynamic range of the original scene isn't huge—the metered exposure contains some marginal shadow clipping, while the +1EV shot only just clips the highlights.

However, adjusting the exposure to get the best possible result in a single, "straight" shot doesn't do justice to the opulence and grandeur of the original scene—there's a fairly dull foreground, an absence of detail in the shadow areas, and a sky that looks pale and washed out. Some of these defects could be at least partially corrected in Photoshop, but HDR Express provides a solution that will allow a much more impressive final image, without the need for any complex post-processing.

−3EV

−2EV

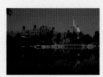
−1EV

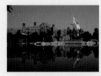
Metered exposure

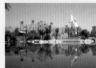
+1EV

+2EV

+3EV

A single exposure of this scene with a Curve applied in Photoshop to slightly boost the contrast (below). It shows minimal highlight and shadow clipping, and could easily be considered an "acceptable" image in its own right. However, shooting a sequence of images and combining them in HDR Express can produce a much better end result.

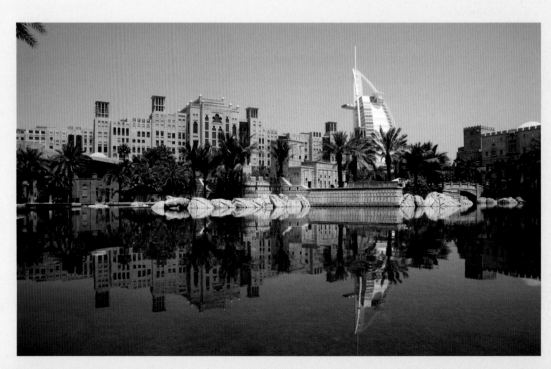

Selecting tone mapping options

As we learned in the previous section on merging the exposure sequence, once the merging is complete, HDR Express runs a dynamic range animation to show you the complete range of tones present in the image. With the dynamic range animation complete, the next step is to choose one of the tone mapping presets in the preset window that runs below or beside the main preview image.

Tone mapping is entirely automated in HDR Express, though there are a number of presets to choose from. These are found in the filmstrip running along the bottom of the screen (see below). These range from Highlight Priority, which will ensure highlights are preserved, to Shadow Priority, which will preserve shadow detail. The default setting is Midtone Priority—which seems to work best on the majority of images—either side of which flank the Shadow-Midtone Priority and the Highlight-Midtone Priority. Once you've selected the tone mapping setting, you can fine-tune the preview using the slider controls in the HDR Controls panel.

HDR Express Controls dialog

Before setting the tone map style, you can fine-tune the preview using the sliders in the Controls dialog, most of which are self-explanatory.

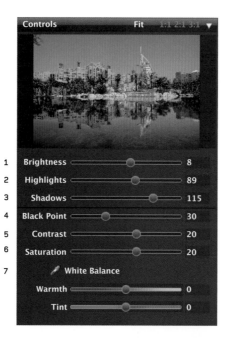

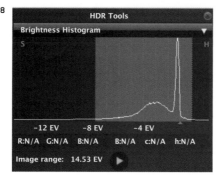

1

Brightness Increases the overall brightness of the image.

2

Highlights Controls the brightness of highlight areas. Move the slider to the right to reduce highlight clipping.

3

Shadows Controls the brightness of shadow areas. Move the slider to the right to reduce shadow clipping.

4

Black Point Sets the shadow levels in the image.

5

Contrast Affects localized contrast, and results in increased or decreased image sharpness.

6

Saturation Runs from a grayscale image (-100) to highly saturated (+100).

7

White Balance White Balance can be set using either a dropper tool, or adjusted using the Warmth and/or Tint sliders.

8

Histogram HDR Express' histogram shows the distribution of tones in an image and clicking on the letters "H" and "S" shows if the highlight or shadow areas have been clipped respectively.

HDR Express Styles

Having selected, and if necessary, fine-tuned the tone mapping preset, click Styles at the far right of the tone mapping preset window to bring up HDR Express' various tone mapping preset styles (*see below*). Presets feature in a number of the more recent HDR programs, including Merge to HDR Pro, Photomatix, and Nik's HDR Efex Pro.

As with these other programs, HDR Express' tone mapping style (1) presets range from the naturalistic, like Optimal (the default), Linear, and Natural, to the more surrealistic and outrageous Artistic and Grunge options. As with the tone mapping options, once you've settled on a tone mapping style you can use the various sliders to fine-tune the preview.

2

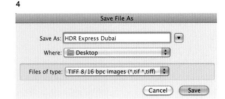

Creating Custom presets

If you find that there are specific settings that complement your style of photography and to which you return time and again, you can create your own personal preset. Click on the blue "+" symbol at the bottom of the HDR Tools panel (2) to bring up the Add Preset window (3) and check the boxes that correspond to the specific settings you want to use. Click OK to save it.

3

4

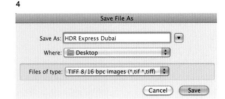

Saving

When you've adjusted the tone mapping settings to your satisfaction, click Save (4). You can save your files either as an 8-bit JPEG, an 8- or 16-bit TIFF, or even as a full HDR 32-bit BEF file, which can be opened in Photoshop with the relevant plug-in. If you intend to carry out further post-production work on the image, save the files as a 16-bit TIFF.

1

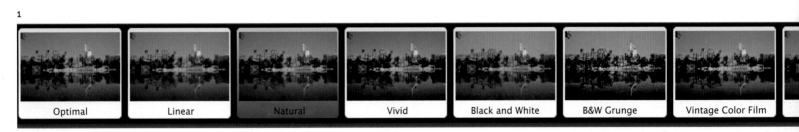

| Optimal | Linear | Natural | Vivid | Black and White | B&W Grunge | Vintage Color Film |

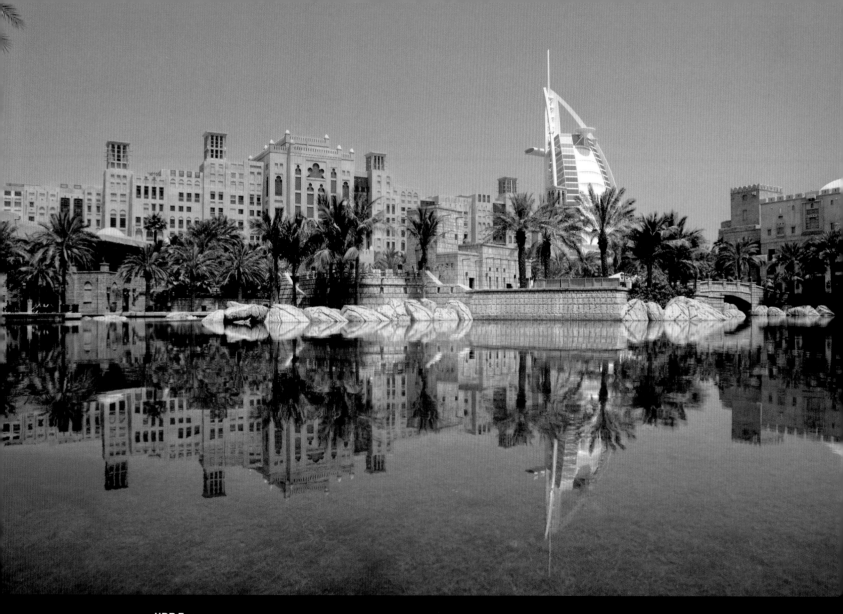

HDR Express

The default Midtone Priority tone mapping preset, combined with the Shadows control to open up some of the shadows provided a good base on which to run the tone mapping styles. As we're aiming for photorealistic results in this section, the Natural tone mapping style was an obvious choice and the final picture is a rich, natural-looking, evenly toned image.

HDR Efex Pro

HDR Efex Pro, from respected software developers Nik, is one of the more versatile and powerful HDR programs currently available. While aimed at photographers who are familiar with image-editing software, and therefore not ideal for beginners, the software offers extensive manual adjustment in the form of numerous sliders and controls as well as providing a wide selection of presets and styles that make it quick and easy to use. The program also features Nik's U Point localized adjustment tool, which we covered in the previous chapter, as well as powerful Curves and Levels commands to accurately control tonal balance and contrast.

HDR Efex Pro Preset Browser

Once the sequence of images is merged, HDR Efex Pro presents the user with an attractive, comprehensive workspace, divided into three main sections. The first column, the Preset Browser (right), provides thumbnail views of HDR Efex Pro's thirty-three different tone mapping style presets—not dissimilar to Photomatix Pro and HDR Express but far greater in number. HDR Efex Pro categorizes the styles into groups, such as Realistic, Artistic, Landscape, Architecture, and so on. However, these are only loose descriptions and you may find that a preset in Architecture works well for a landscape image, for example. It's also possible to set up your own custom presets to use.

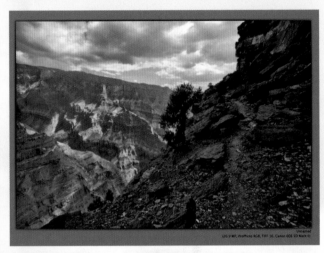

HDR Efex Pro preview screen

The central portion of the workspace is taken up with the main image preview. The view can be changed from one large preview to two comparative options—one split screen, or two small side-by-side images as shown above.

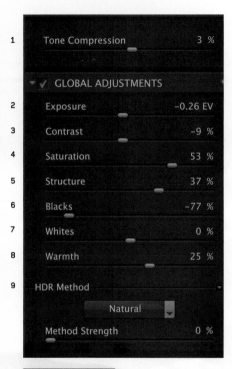

HDR Efex Pro control dialog

HDR Efex Pro provides you with an excellent level of control in the form of a number of sliders, commands, and presets. The controls are grouped into three collapsible sections, (Global Adjustments, Selective Adjustments, and Finishing Adjustments), which are covered on the next page. Each section can be switched on and off by clicking the small check box. Again, many of the slider adjustments are self-explanatory.

1

Tone Compression Similar to Photomatix Pro's Tonal Range Compression slider, HDR Efex Pro's Tone Compression control is the most important overall adjustment. It determines the tonal range in the final image; moving the slider to the right will gradually darken highlights and brighten shadows so that the image displays a complete range of tones .

Global Adjustments

2

Exposure Adjusts the brightness of the image, ranging from −3EV with the slider all the way to the left, to +3EV with the slider set to the far right.

3

Contrast Controls the contrast in the image, ranging from −100 percent to +100 percent .

4

Saturation Sets the level of color present in the image from a color-free grayscale of −100 percent at left, to full +100 percent color saturation to the right.

5

Structure Acts like a micro contrast control, and helps to emphasize fine details and texture in the image.

6

Blacks Sets the black (shadow) level in the image. Moving the slider to the right increases the number of pixels that become black.

7

Whites Sets the white (highlights) level in the image. Moving the slider to the right increases the number of pixels that become white.

8

Warmth This slider adjusts the color temperature of the image. Move the slider to the left to cool down the image, and to the right to warm it up.

9

HDR Method The HDR Method pull-down menu provides access to twenty preset algorithms, ranging from Natural, through Diffused, to Harsh Details. The strength of the HDR Method can be adjusted using the Method Strength slider.

Selective Adjustments

Localized adjustments can be made using the HDR Efex Pro Control Points. The adjustments available are the same as those offered under the Global Adjustment menu. See pages 55–56 for a complete description of how to use Control Points.

Finishing Adjustments

HDR Efex Pro's Finishing Adjustments are applied once you've finalized the tone mapping settings. There are two main commands; Vignette and Levels and Curves.

1

Vignette Vignettes create a dark or light border around the image, focusing the viewer's attention on the central subject. You can use the various sliders to create a vignette to whichever size and shape you want or use one of the eight presets (below).

2

Levels and Curves The Levels and Curves controls work in much the same way as Levels and Curves perform in Photoshop. You can use the curve and black-and-white point sliders to customize tone and contrast, or use one of the eight presets (below).

Vignette presets

Curves presets

3

Loupe & Histogram At the bottom of the control dialog is the Loupe & Histogram view. You can toggle between the two. The histogram provides data for red, green, and blue channels. To fix the loupe view on a specific part of the image, use the pin icon.

Photorealistic with HDR Efex Pro

HDR Efex Pro is sufficiently versatile to produce both photorealistic and hyper-realistic images. For the first style, use one of the Realistic preset tone mapping styles, and set low Tone Compression and Method Strengths. Also avoid over-saturating the image as this can create an unrealistic representation.

+2EV

Metered exposure

−2EV

Using the Realistic (Strong) preset on three source images has provided a well-balanced result with contrasting clouds and well-exposed foreground. Although now tonally balanced the image still looks natural.

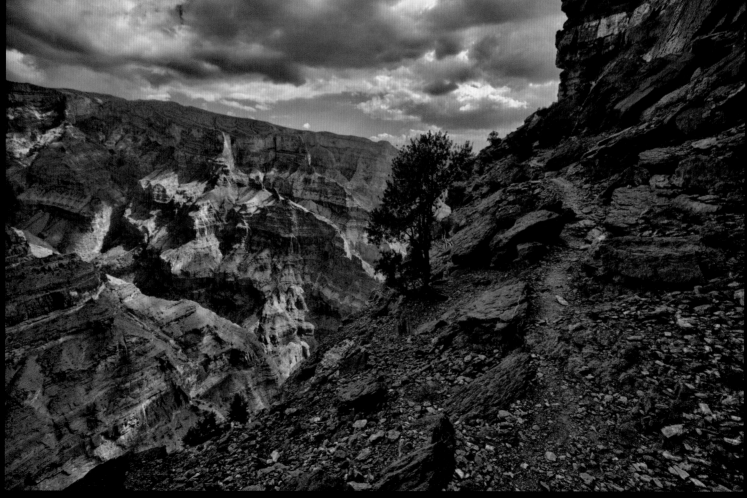

Oloneo PhotoEngine

Of all the HDR programs covered in this book, Oloneo's PhotoEngine is the one that's most geared toward the professional photographer. With its four tone mapping algorithms and a good selection of manual control—both in terms of tone mapping settings and adjustment for the LDR output image—PhotoEngine is a powerful HDR program that is capable of producing results that are as good as, and often better, than any of the other programs discussed.

PhotoEngine's Presets

As with HDR Efex Pro, PhotoEngine's workspace is attractive, easy to navigate, and arranged into three discreet sections. PhotoEngine's Presets are found in the first column on the left hand side of the workspace and provide the user with forty-two presets to choose from. These are arranged in sixteen categories, ranging from photorealistic, through black and white, to the highly surrealistic. As with the other programs it's easy to create your own presets as soon as you arrive at tone mapping settings that you particularly like.

PhotoEngine's Timeline

PhotoEngine's Timeline records all the changes made to a specific image, rather like the History command in Photoshop. You can click on any specific line to return to that point in your editing, and any changes made above that line will be deleted as soon as you perform another edit. Click the Interactive Preview box to see the image adjust as you move the cursor up and down the timeline. When you like the way your image is looking, but still want to try other settings, click the Add Version button to create a version of the image you can return to instantly.

PhotoEngine's Image Window

One of the most signficant advantages PhotoEngine has over its HDR rivals is the image it displays. This is not just a preview, but an accurate representation of how the image will appear when the tone mapping process is completed. With some HDR programs the preview can vary quite drastically from the final tone mapped image, but with PhotoEngine the displayed image matches exactly the final result.

Another benefit of PhotoEngine is that adjustments are made in real time: you move the sliders, the image changes. With other software you have to release the mouse button for the adjustment to take affect. This makes using PhotoEngine a more precise, less hit-and-miss affair.

One other final comment to make about PhotoEngine's display is that the image is always shown at full resolution. Simply click on the image to zoom in to any part, use the cursor to navigate around the image, and click again to zoom out. The process is quick and intuitive and the display extremely accurate.

The Info panel shows the image's histogram, and displays the red, green, and blue channels separately. Point at a pixel with the cursor to find out its RGB value.

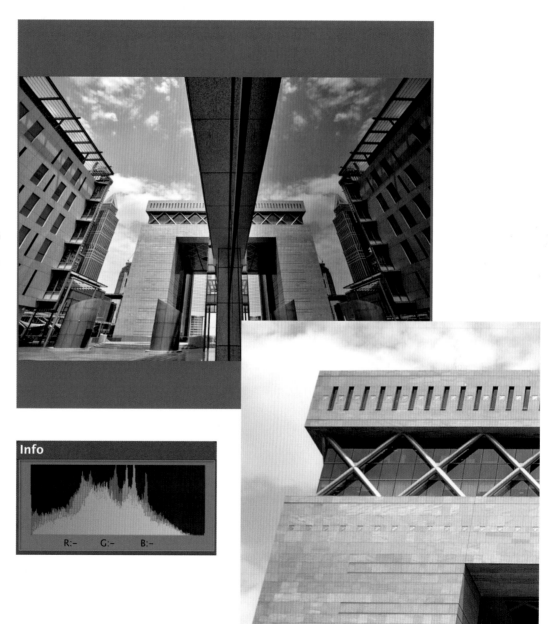

Info

R:– G:– B:–

1

1

Auto Tone Mapper The Auto option only features one slider. According to Oloneo, powerful algorithms assess the brightness and saturation values across the image and the slider then controls highlight/shadow recovery, contrast, exposure, brightness, and saturation. Moving the slider to the right adjusts the image in real time, from natural to surreal.

2

High Dynamic Tone Mapping

2

Local Tone Mapper This is the default tone mapping option, and in the majority of cases provides you with all the necessary level of control you need.
TM Strength Controls the overall strength of the tone mapping effect. The higher the value, the darker the highlights become and the brighter the shadows. TM Strength can be set to negative values to darken shadows and brighten highlights to create more contrast.
Detail Strength Controls the detail contrast or micro contrast in the image. Move the slider to the right to emphasize texture and detail.
Auto-Exposure In most cases PhotoEngine will automatically set the most accurate exposure, so check the check box. However, you can fine-tune the setting with the Exposure and Fine Exposure sliders.
Auto-Contrast As with Auto-Exposure, PhotoEngine will set the optimum contrast setting, which you can amend using the Contrast slider should you wish.

3

Advanced Local Tone Mapper As well as all the settings available in the Local Tone Mapper option, the Advanced Tone Mapper provides some additional control.
Detail Size Determines the size of the objects PhotoEngine classifies as "details." The lower the setting the smaller the objects are that PhotoEngine identifies as details.
Detail Threshold Draws on luminance values to determine what classifies as detail or not. Both these settings are useful when reducing halo artifacts.
Edge Sharpen This is another localized contrast control that can help reduce or control HDR artifacts that sometimes appear in very high-contrast areas.
Panorama Mode Check this option when creating 360° HDR panoramas. It ensures that the same values are applied to edges that join.

4

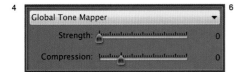

4

Global Tone Mapper This option is most effective on images that have only a medium dynamic range, and for which you want a photorealistic result.
Strength Increasing the Strength slider recovers detail in highlight areas.
Compression Increasing the Compression slider recovers detail in the shadows.

5

5

Natural HDR Mode As this option suggests, enabling this mode will help make sure that your images appear more natural. The program uses sophisticated algorithms that set natural-looking color, tone, and contrast.

6

6

Low Dynamic Tone With the tone mapping settings completed, you have the option of adjusting Exposure, Brightness, Saturation, and Contrast in the LDR image before saving. Clicking the Linear Raw box ensures that any tone curve previously applied to the image is removed. Here you can also adjust the white balance of the image using either the preset pull-down menu, the Temperature or Tint sliders, or the color wheel. Alternatively click on the eye dropper tool at the top of the image window and select a neutral area.

7

7

Photographic Print Toning This is a powerful tool for creating duotones or emulating chemical toning in conventional printing, such as sepia or selenium toning. The left side controls the shadow regions, the right side affects the highlights. The horizontal sliders determine color saturation, while the circular color wheels allow you to choose the hue. The Mix slider at the bottom of the dialog determines whether emphasis should be placed on the shadow or highlight regions.

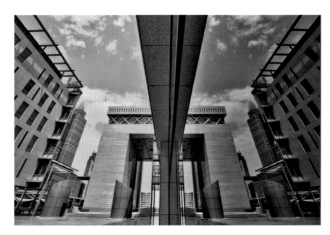

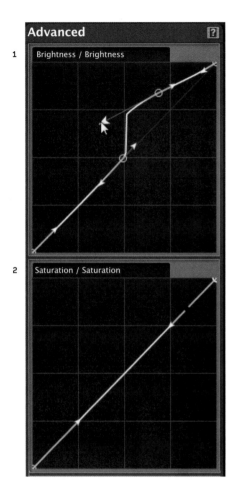

Advanced

Found under the Advanced tab of the control dialog are an additional five commands that you can utilize to finalize the look of your LDR image.

1

Brightness/Brightness This works in much the same way as the Curves command in Photoshop, and allows you to adjust the brightness in specific tonal regions of the image, such as the shadows, midtones, and highlights. The top right section of the curve represents the highlights, the lower left section the shadows. Click on the curve to add points, and drag the curve to make the adjustment. You can also drag on a point or a tangent arrow to adjust the shape of the curve (in the same way you draw Bézier curves in Photoshop).

2

Saturation/Saturation Works in much the same way as the Brightness curve, but adjusts color saturation. The straight line represents the color saturation of the original image. To increase or decrease saturation in low-saturated areas, move the bottom left half of the curve up or down, and to increase or decrease saturation in highly saturated areas, move the top right section of the curve up or down.

3

Hue/Saturation This controls the saturation of the given colors. Move the target up to increase the saturation of a color, or move it down to desaturate it.

4

Hue/Luminance This controls the brightness or luminance of the colors.

5

Hue/Hue This shifts the hues of the colors to alternative hues.

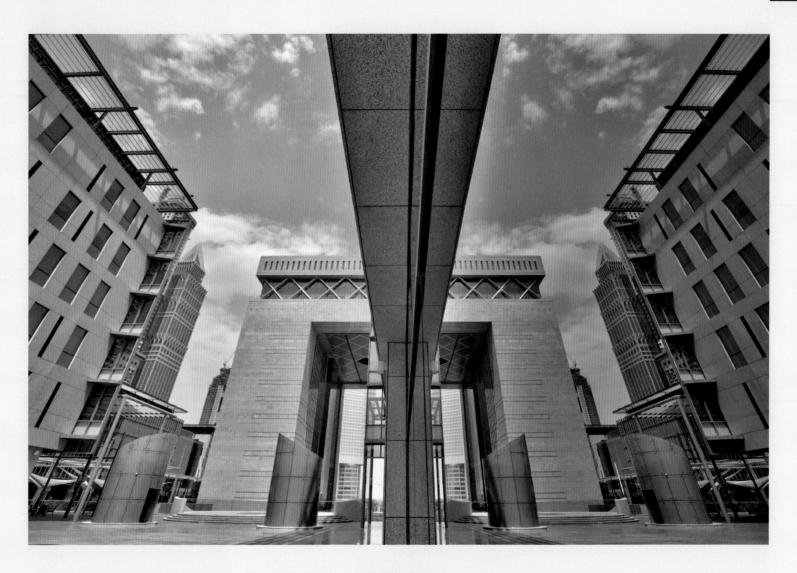

Photorealistic images with PhotoEngine

This photorealistic image of buildings
in Dubai was created using the Natural
More Details tone mapping preset. This
automatically sets Natural HDR Mode
to Enable for a naturally colored image.

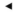

Untitled
Ricardo Aguilar Herrera

◄

End of another great day
Michael Steighner

Photomatix Pro 3.1
Details Enhancer settings

Strength: 100
Color Saturation: 79
Luminosity: 5
Light Smoothing: High
Microcontrast: 1
White Point: 0.029900
Black Point: 0.202350
Gamma: 1.214195
Temperature: 0
Saturation Highlights: 0
Saturation Shadows: 0
Micro-smoothing: 2
Highlights Smoothing: 0
Shadows Smoothing: 71
Shadows Clipping: 0

◄

Heading across the Everglades
Michael Steighner

Photomatix Pro 3.1
Details Enhancer settings

Strength: 84
Color Saturation: 63
Luminosity: 4
Light Smoothing: High
Microcontrast: 3
White Point: 0.558550
Black Point: 0.334800
Gamma: 1.283426
Temperature: 2
Saturation Highlights: 0
Saturation Shadows: 0
Micro-smoothing: 2
Highlights Smoothing: 0
Shadows Smoothing: 0
Shadows Clipping: 0

▶
Plant in operation
David Nightingale

▼
Barcelona #4
David Nightingale

WARNING
CONSTRUCTION
PLANT IN
OPERATION
PLEASE KEEP OUT

◄
Sunset at Sebring
Michael Steighner

Chapter 5:
Creating Hyper-real HDR Images

Photomatix Pro:
The Details Enhancer

In this section, before moving on to a more detailed look at a finished example, I am going to work through the steps you need to take to tone map an image using Photomatix Pro's Details Enhancer. We're focusing on Photomatix Pro initially as this is one of the most popular HDR programs available, and the Details Enhancer is particularly adept at creating the hyper-real look. We'll be looking at other HDR software later in the chapter.

Photomatix Pro's Details Enhancer works by maximizing the tonal range within specific areas of an image, so there will be a lot of contrast in the sky, there will be a wide distribution of tones in foreground detail, and so on, based on the data available from your original sequence. This is one reason why it is crucial that your original exposure sequence captures both the shadow and highlight detail within in an image,

because if none of the shots in the sequence contains detail in the darkest areas of a scene there will be no detail in these areas in the final tone mapped image. Likewise, if all the shots in your sequence contain clipped highlights, this will also be incorporated into the final image. For this introduction we will use a seven-shot sequence (with a 1EV spacing), that clearly cover the entire dynamic range of the original scene.

Having generated our 32-bit HDR file as discussed in chapter three, we are ready to begin tone mapping the image. The Details Enhancer is Photomatix Pro's default tone mapping option, and on first sight the dialog can seem quite confusing. Over the following pages we will make sense of all the options.

−3EV

−2EV

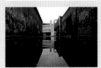

−1EV

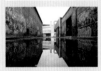

Metered exposure

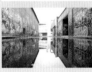

+1EV

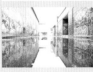

+2EV

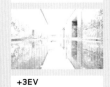

+3EV

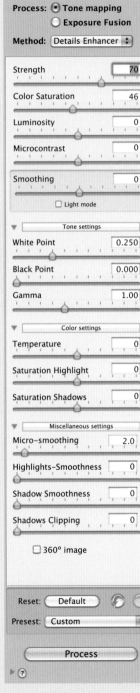

The Details Enhancer controls

The histogram for the −3EV exposure

The histogram for the +3EV exposure

Strength

The Strength slider operates as a "master control" for the rest of the Details Enhancer adjustments. This means that when it is set to zero it almost cancels out any change you might make elsewhere, so to get the full benefit of the Details Enhancer you need to set a value larger than zero. As you go through the various changes—not just Strength—it's worth keeping an eye on the histogram as it provides useful feedback about the relative distribution of tones within the image and how these are affected by the changes you make to the settings.

The default value for the Strength slider is 70 percent, but I generally find that a value of 80–100 percent produces more interesting results. In this example, when the Strength is increased to 100 percent the contrast is intensified throughout the image, but the really interesting effect is the increase in local contrast—there's a lot more detail in the brickwork, graffiti, and sky.

Color Saturation

This slider is self-explanatory, and operates in much the same way as the Saturation slider in Photoshop's Hue/Saturation tool (a value of zero produces a black-and-white image, while increasing the value increases the saturation).

Luminosity

The Luminosity slider controls the extent to which the tones in your image are bunched together, or compressed. Adjusting the luminosity slider also affects the overall brightness of the image, so in the example images I have also adjusted the Gamma slider (which is like the gamma slider in Photoshop's Levels tool), so that each example has roughly the same brightness level. This confuses things slightly (I'm making two changes at the same time), but it does a better job of illustrating the changes that the Luminosity slider can make.

With the Luminosity set to -10 (and the Gamma at 0.48) you can see this has the apparent effect of lessening the local contrast and tonal compression within the image.

If the Luminosity slider is set to +10 (and the gamma slider to 0.96), a much more striking image is produced, with considerably more local contrast and tonal compression.

Because changes to the Luminosity nearly always require a related change to the Gamma, this setting can take some time to get right, but it can make major changes to the final appearance of your image.

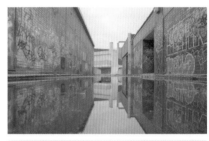

Strength: 0

Strength: 100

Luminosity: -10

Luminosity: +10

Microcontrast: –10

Light Smoothing: Min

Light Smoothing: Mid

Microcontrast: +10

Clicking the Light mode check box in the
Smoothing command switches the control
from a slider to a series of five Light
Smoothing options.

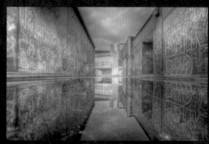

Light Smoothing: Max

Microcontrast

The Microcontrast slider controls the
"level of accentuation of local details."
In other words, it affects the local
contrast in different parts of the image.
As with the Luminosity slider, alterations
to the Microcontrast slider can also
affect the overall brightness of the
image, so in the two examples I have
included here I have also altered the
Gamma to keep the overall brightness
consistent. The difference is subtle, but
you can see that when the Microcontrast
is increased, the contrast within specific
sections of the image also increases.

Smoothing

Light Smoothing can be controlled
in two ways, either as a slider (ranging
from –10 to +10), or, after clicking
the Light mode box, as a series of
five options ranging from Min to Max.
However you choose to set the
Smoothing control, setting a very low
value will result in halos around objects,
particularly those that have edges
against the sky or a smooth background,
and the image will lack contrast.

If you select a very high setting, you
will have something that appears more
realistic, with no obvious haloing and a
more even tonal distribution. However,
you also lose the slightly surreal quality
that typifies many HDR images.

Between these two extremes, a Mid
setting produces an image that looks
much more interesting. Although there
is some minor haloing along the tops
of the walls (that could be fixed in
Photoshop), the foreground and walls
seem better lit, the tones are more
evenly distributed throughout the image,
and the HDR "look" has been retained.

As a general rule (and this is an esthetic,
rather than technical recommendation),
I would suggest that you set the
Smoothing control to the point at which
any obvious haloing is removed. If you
would prefer a more photorealistic
result, turn it up a bit further, while
for a more surreal result turn it down.

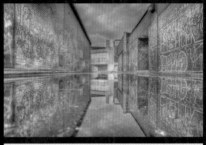

Temperature: -5

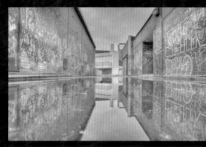

Micro-smoothing: 30

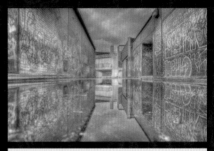

Temperature: +4

Tone Settings

The controls within the Tone Settings section of the dialog might be more familiar than some of the other tools. We have already mentioned the Gamma slider, which can be used to adjust the overall brightness (or "exposure") of the image. The other two sliders—White Point and Black Point—operate in the same way as the white and black point sliders in most editing-programs' Levels or Curves tools, allowing you to manipulate the white and black points of your image. Unless you have a very compressed histogram, I would suggest that you leave both of these set to zero and adjust the white and black points during post-production, rather than risk clipping either the shadows or highlights at this stage of the process.

Color Settings

The controls in the Color Settings section are reasonably self-explanatory, especially the Temperature slider that allows you to shift the white balance of the tone mapped image. Dragging the slider to the left will produce a cooler, bluer image, while dragging it to the right adds a warmer cast to the picture. The Saturation Highlights and Saturation Shadows sliders simply control the saturation of the highlight and shadow areas respectively. These are often quite useful, as tone mapping an image using the Details Enhancer can add a dispro-portionate amount of saturation to the shadow areas of an image.

Miscellaneous Settings

There are four controls in the Miscellaneous Settings section, the most significant of which is the Micro-smoothing slider. This can be used to smooth out the local detail enhancement added by the Microcontrast slider which, when used at higher settings, can introduce noise into the final image, especially in the sky or other areas of the image containing reasonably smooth tones. The default setting for this slider is 2, but it can be set anywhere between 0 and 30. Using the maximum setting of 30 produces a similar result to setting the Microcontrast to -10, so it's clear that very high Micro-smoothing cancels out the effect of a Microcontrast adjustment, producing an image that more closely resembles a "normal" photograph.

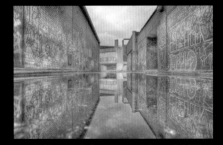

Highlight Smoothing: +45

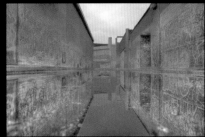

Highlight Smoothing: +100

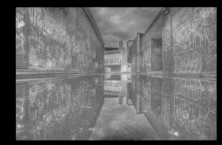

Shadows Smoothing: +100

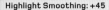

Miscellaneous Settings (continued)

Both the Highlights Smoothing and Shadows Smoothing sliders allow you to moderate the global adjustments that you have made to your image at either end of the tonal range, but not the midtones, so you can turn down the tone mapping in the highlight areas and shadow areas respectively.

Of the two controls, Highlights Smoothing is probably the most useful as it allows you to control the effect of the tone mapping on the skies within your images, an area that can often look over-processed or contain high levels of noise. As with all the controls within the Details Enhancer dialog, the actual settings you need will vary from image to image, but in this instance

a Highlights Smoothing setting of 45 produces a final version where the sky looks quite natural. Increasing the value to 100 affects the brighter areas in the rest of the scene, resulting in a flat, dull image, with very little highlight detail.

For the majority of images, the Shadows Smoothing control is less useful, as it will be rare that you need, or want, to moderate the effects of any adjustments to local contrast in the darker areas of your image. If you do use it, you need to be careful not to set too high a value as, like the Highlights Smoothing option, this can produce a dull-looking image.

The final tool falling under Miscellaneous Settings allows you to intentionally clip the shadows in your tone mapped image. This can be useful if you want to reduce the amount of noise in the darkest areas. However, clipping the shadow detail at this stage isn't a good idea, because the preview window isn't entirely accurate (so it can be difficult to judge exactly how much clipping will occur), and this is a task that can be performed much more accurately in your image-editing program.

That finishes off the tools in the Details Enhancer and what they do, so now it's time to put it into practice. Over the following pages we will explore these controls in a bit more detail, and work through an example that will show you how to optimize the settings to produce images that meet your creative expectations.

The Details Enhancer: Worked Example

-2EV

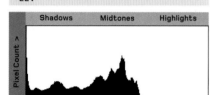

Histogram for the -2EV exposure

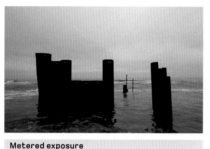

Metered exposure

Histogram for the metered exposure

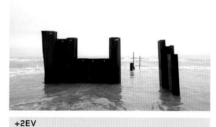

+2EV

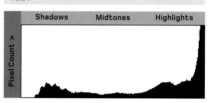

Histogram for the +2EV exposure

As you can see from the images and histograms of this three-shot sequence, this scene is a good candidate for HDR. The EV range is higher than the dynamic range of the camera's sensor, and the interesting detail in the metal structure has been all but lost in the metered exposure. A single shot of this scene—even if it could have captured the entire dynamic range of the original scene—wouldn't have been especially interesting.

Before we go through the various stages of processing this sequence, it's worth taking a look at the histograms for each of the images to see what I did wrong, or rather, how this sequence could have been done better.

If you look at the darkest exposure, you will see that there is quite a lot of room at the rightmost edge of the histogram, so while it captures all of the highlight detail in the original scene, it's quite a bit darker than is necessary.

By the same token, while the lightest exposure has recorded all the detail in the darkest areas of the image, the gap at the leftmost edge of the histogram is very small. What this indicates is that the metered exposure isn't ideal—the entire sequence of images should have been overexposed by around two-thirds of a stop. This would have lightened the darkest exposure (which would still have captured all the highlight detail), but more importantly, it would have lightened the lightest image, so the detail in the darkest shadows would have been recorded using more data.

However, despite this, creating the HDR image from the three initial exposures was a straightforward process—the only choice I made that was especially significant was to select the option to attempt to remove the background movement, in this case caused by the small waves moving between the three exposures.

While I tend to prefer more extreme HDR images, I always take a quick look at how the default settings within Photomatix Pro will tone map the image, not least because this provides a uniform starting point with which to evaluate the various sequences I process. In this instance (1), the default settings provide a good starting point; there's a nice tonal balance between the metal structures and the rest of the image, and a reasonable amount of detail in both the metal and the waves. There is still room for improvement though.

The first step is to increase the Strength, in this instance taking it all the way up to 100 (2). The image immediately looks better as the sky is a bit darker, the structure and foreground a little lighter, and the detail in the metalwork has been accentuated.

1

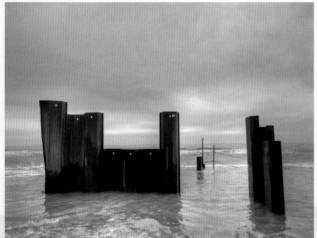

Tone mapped using the default settings

2

Strength: +100

3

Histogram with Strength set to +100

4

Histogram with White Point and Gamma adjusted

5

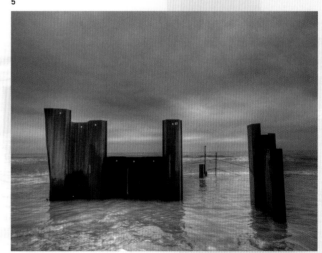

Increasing the Microcontrast and Luminosity

Microcontrast: +5	
Luminosity: +3	
Gamma: 1	

However, the histogram in the Details Enhancer dialog (3) shows that increasing the Strength has caused some minor clipping to the highlights. To correct this, I reduced the White Point to 0.015 and decreased the Gamma to 0.91 to compensate for the decrease in brightness caused by altering the white point.

This doesn't make a huge change to the appearance of the image, but it does bring back the highlights (4), so that the very brightest highlight detail will be retained in the final image.

The next three changes I made were to increase the Microcontrast to +5, the Luminosity to +3, and the Gamma back to its default value of 1 (5). The first of these changes increases the fine scale detail in the tone mapped image, and with this image the effect is most noticeable in the metal structure, with the rust,

scratches, and marks left by the waves all becoming more pronounced.

The change to the Luminosity requires a little more explanation. As explained, the Luminosity slider controls the amount of tonal compression in an image, so increasing the Luminosity means the tones within an image become more compressed. However, at the same time this gives the appearance of an increase in local contrast. In other words, this change further accentuates the fine scale detail within the image.

The third change—resetting the Gamma slider to its default value—compensates for the previous two changes, which also lightened the image. Generally speaking, you will find that you will need to adjust the Gamma slider quite frequently to compensate for changes introduced using other controls and sliders.

6

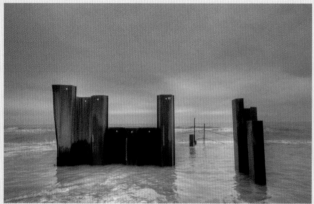

Micro-smoothing: 15

**Increasing the
Micro-smoothing**

To reduce the noise in the image, I increased the Micro-smoothing to 15 (6), but this had two negative consequences. First, it made a global change to the image, reducing the local contrast in all areas and producing an image that was noticeably less striking.

The second consequence of this change was that it also removed a lot of the fine scale detail in the foreground—detail that can't be added in any post-processing. So in this case, resetting the Micro-smoothing and generating an image with an unacceptable amount of noise preserved both the overall appearance of the image I was aiming for, and retained the fine scale detail in the metal structure. The noise can be dealt with later.

In terms of the other Details Enhancer settings, I left these all at their defaults, choosing not to make any color changes or alterations to the Light Smoothing and other options. With the tone mapping complete it was time to press Process and wait for my image to be generated.

Post-production

After saving the tone mapped image as a 16-bit TIFF, the file was opened up in Photoshop for some final adjustments. I started by increasing the global contrast using the Curves tool (as described in the next chapter). With most tone mapped images, unless you adjust both the White Point and Black Point sliders to clip the highlights and shadows when you tone map an image, it will be inevitable that the final image will look a bit flat. In these cases, the Curves tool is ideal for reintroducing some contrast into an image, without clipping the shadow or highlight detail.

I then fixed the haloing above the top of the metal pillar on the left of the image. This isn't the only visible haloing—it's also evident right along the top of the structure—but it was only this section of the image where it seemed especially distracting. Again, this technique is covered in the next chapter.

Finally, I used Noiseware Professional to remove the noise. It's now a big improvement on any of the original shots in the exposure sequence, and a far more striking photograph.

Photomatix Pro 4.0 Details Enhancer settings	
Strength: 100	
Color Saturation: 60	
Luminosity: 3	
Light Smoothing: Medium	
Microcontrast: 5	
Micro-smoothing: 2	
Highlights Smoothing: 0	
Shadows Smoothing: 0	
Shadows Clipping: 0	
Gamma: 0.91	

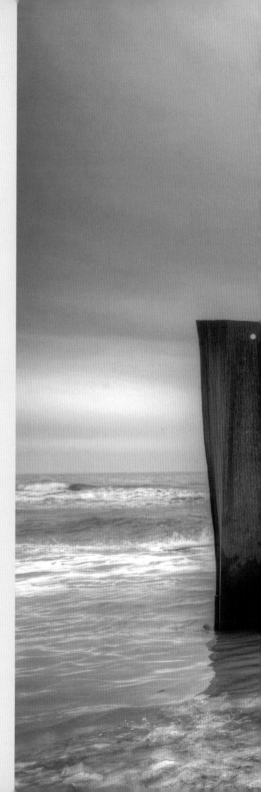

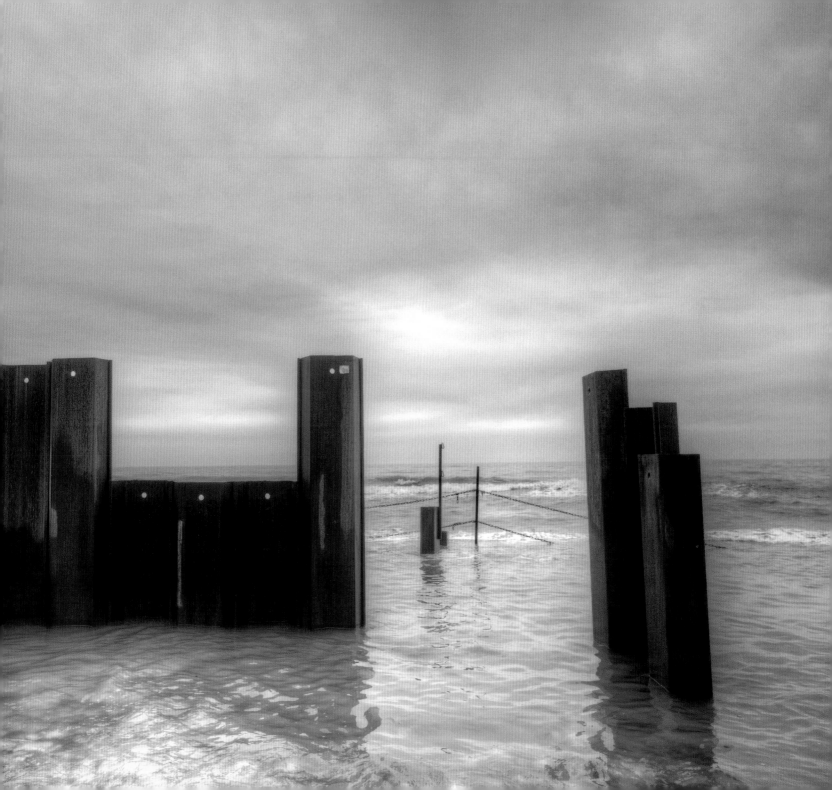

Photoshop Merge to HDR Pro

−2²/₃EV

−1²/₃EV

−²/₃EV

Metered exposure

+1¹/₃EV

+2¹/₃EV

+3¹/₃EV

In the previous section we saw how successful Photoshop is at producing photorealistic images. One criticism of Photoshop's HDR command in the past has been that, although capable of producing realistic results, it was less good at creating more artistic images. While the final appearance of an image is largely determined by the program you use to tone map the HDR image (and the strength and type of the settings you apply), the original scene also contributes strongly to how real or unreal the final image will appear. Specifically, when you photograph a scene that covers a very large EV range, or when areas of the original scene would naturally be either very bright or very dark, an HDR image can look unreal, or hyper-real, despite your intentions to the contrary. The reason for this is that the final picture will look radically different to our expectations of how that scene *should* appear. In other words there is such a striking mismatch between our perceptual expectations and the final image that the picture inevitably looks unreal.

Using Photoshop's Surreal preset is often a good place to start when attempting to create a hyper-real style. However, although this has produced an image with impact, too much of this particular photo has blown out in the highlights and there are bright halos around the trees in the background.

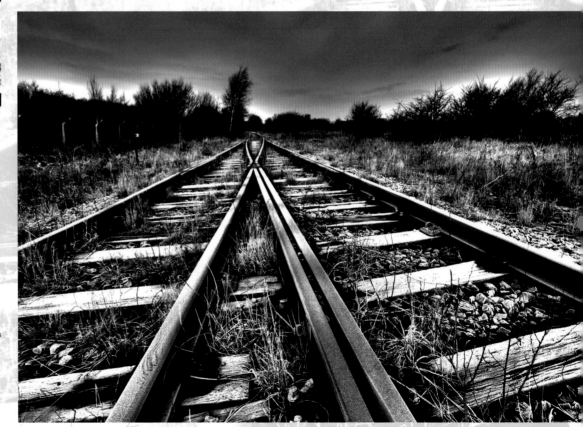

My reason for reiterating this are twofold. If you can develop a better understanding of the various processes that go into constructing an HDR image, and the relationship between the EV range of the original scene and how this can be translated into a tone mapped image, you will have a much better chance of producing good results. Second, while Photoshop is perhaps better suited to producing photorealistic images, it can also be used to produce hyper-real or surreal results when given the right set of original exposures.

Resetting to the Default preset option provides us with an evenly toned image, and a good place to start again with some manual adjustments. With an image such as this one, which features grass and trees, check the Remove Ghosts box so that you get a really sharp image with no ghosting blur.

Detail

If you're going to use Photoshop's Merge to HDR Pro command to create a hyper-real image, the best place to start is with the Detail slider. If you remember in the last chapter, the Detail slider increases sharpness in the image, and acts in a similar way to the micro-contrast slider in Photomatix Pro. You can be quite forceful with this control—here I've set Detail to 250 percent. It's certainly increased the level of detail and texture in the image, but has introduced some halos.

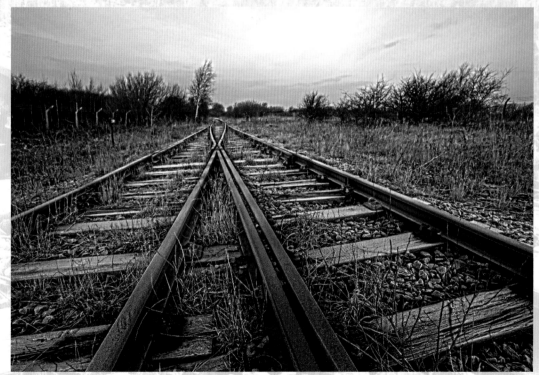

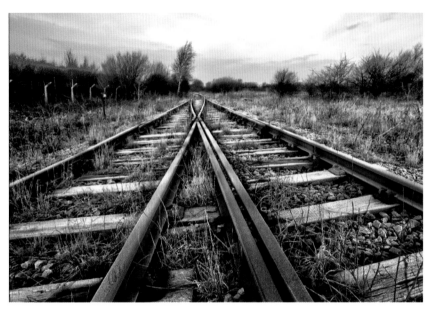

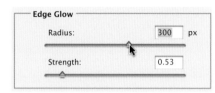

Radius

To combat the oversharpened effect you get with a high Detail setting, but without losing the strong texture we want for our hyper-real image, turn to the Radius slider. This increases the size of the areas of localized brightness, and in this image helps to reduce the halos around the trees. Aim for a setting that provides a compromise between retaining texture and detail while at the same time softening the sharpening effect. In this instance a value of 300 works.

Saturation

The next step is a personal preference for this particular image. With this shot I've chosen to desaturate the image as it gives it a more gritty realism. All I've done is take the Saturation level down to 0; the adjustment is subtle but discernible.

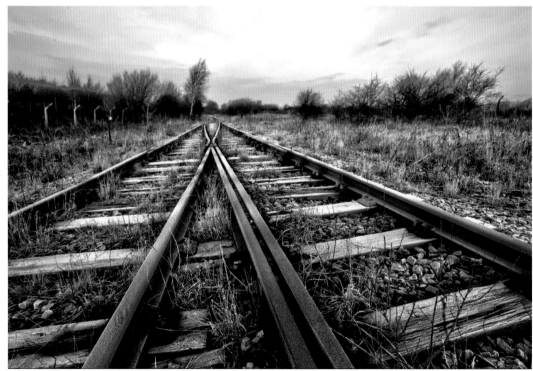

Curve

The next adjustment is more radical. Using the Curve command, I've created a reverse "S" curve. This darkens the sky and brightens the foreground, reinforcing the unreal nature of the image.

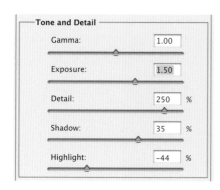

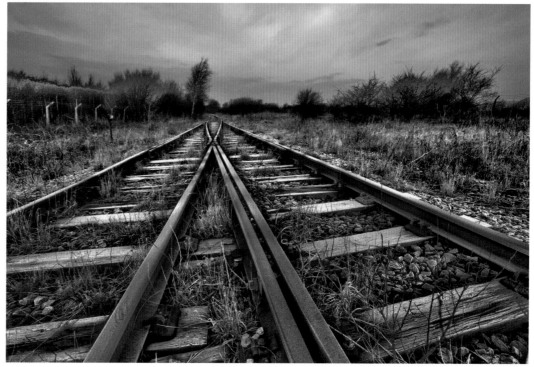

Exposure/Highlights

To finish I increased Exposure to lighten the image a little, but used a negative Highlight setting to hold the gray sky. I also reduced Saturation again to combat the additional color added to the image by the Curve adjustment.

HDR Express

-2²/₃EV

-1²/₃EV

-²/₃EV

Metered Exposure

+1¹/₃EV

+2¹/₃EV

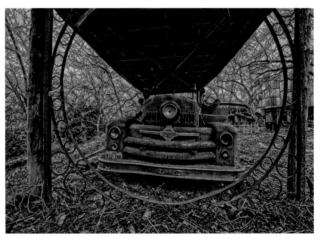

Produced using HDR Express Natural preset

HDR Express is very quick and easy to use, but is this at the cost of the flexibility you often need to create strong hyper-real HDR images?

Using a sequence of six exposures of this old Austin truck, we'll see if we can obtain a successful hyper-real shot. The scene has lots of strong lines and plenty of texture to exploit, and shows a dynamic range just about on the edge of the camera sensor's maximum sensitivity.

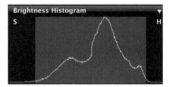

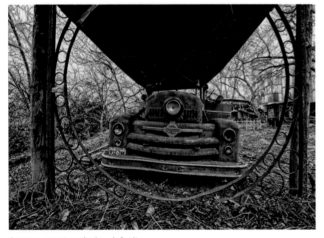

Grunge preset applied as default

Grunge preset applied with increased Shadows slider

Grunge Preset

A very quick and easy option to create the surreal, hyper-real quality is to use HDR Express' Grunge preset. With the preset applied as default the shadows were too dark and losing detail. However, this is quickly addressed by increasing the Shadows slider, which brightens shadows and brings back some detail.

HDR Express and post-production

Although the HDR Express Grunge preset has created an acceptable result, an alternative option is to use HDR Express to create a tone mapped base image that can then be edited in image-editing software for a more subtle finish.

When creating a tone mapped image for post-processing, and you want your final image to have a balanced tonal range, aim to produce a flatter, less contrasting image initially. Although it may seem counterintuitive to start by creating a dull-looking image, you'll end up with a better result in the end.

If you compare the histograms of the Natural image with that of the flatter image, you'll notice that the tones are bunched toward the center of the histogram in the flatter version. This means that when contrast is increased later, it will be increased uniformly across the different areas of the picture.

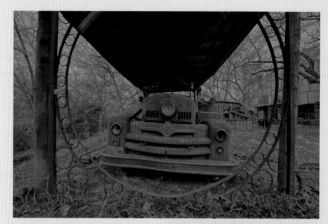

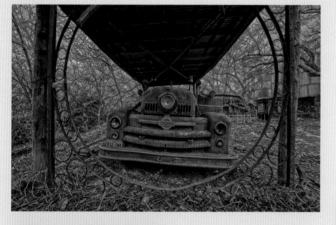

Tone mapped image with deliberately compressed tones. Increasing the Highlights setting helped to flatten the image.

The next step was to increase the Contrast setting to make the most of the textures present in the scene.

In the final post-production stage, a Curves command was applied using Photoshop to increase contrast. I then duplicated the background layer, applied a gentle Diffuse Glow filter setting to the new layer, and set Opacity to 60 percent. The final hyper-real image is subtler and lighter in tone than HDR Express' preset.

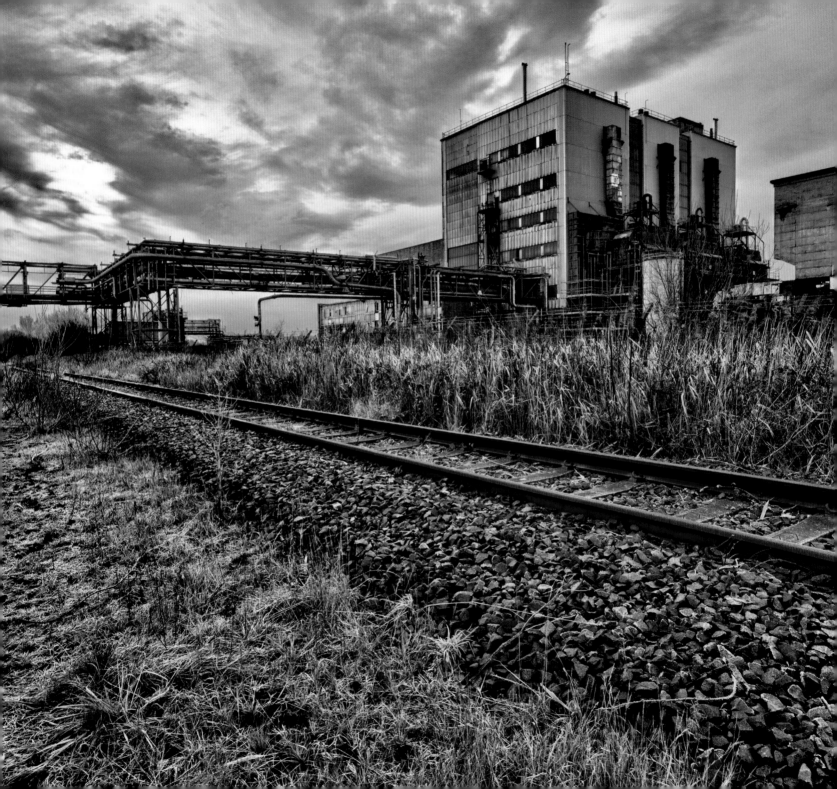

HDR Efex Pro

When it comes to creating surreal HDR imagery, HDR Efex Pro excels. Our initial look at the software in the last sections revealed the good number of preset options available combined with a high degree of manual control, particularly in the shape of the Control Point functionality. This versatility is ideally suited for more artistic HDR projects.

Using HDR Efex Pro to create a hyper-real image reveals a vast array of options, some of which we'll look at here in more detail.

-4EV

-2²/₃EV

-1¹/₃EV

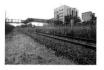

Metered exposure

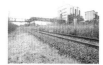

+1¹/₃EV

Step 1: This sequence of an industrial complex is ideal material for a hyper-real image. There's plenty of texture in the form of both the natural vegetation in the foreground and middle of the frame as well as the rocks acting as ballast for the rail tracks. The cloudy sky also creates a glowering atmosphere, which can be exploited by a hyper-real treatment.

Step 2: One of HDR Efex Pro's Preset Categories is Surreal. Here there are six preset options, with suitably surreal names such as Granny's Attic and The Old Cottage. But among these you can also find Bleach Bypass Look, which with the right sequence can create a hyper-real look.

★ 18 Bleach Bypass Look

Step 3: The Bleach Bypass Look has removed too much detail from the sky. Using two Control Points and reducing the Exposure setting helps to reintroduce the clouds, and add to the drama of the scene.

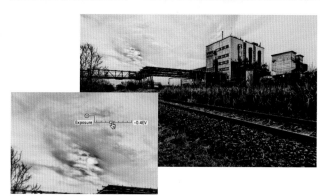

Step 4: In the final image the preset shows off the texture to good effect, and the desaturated colors reinforce the unnaturalness of a hyper-real image.

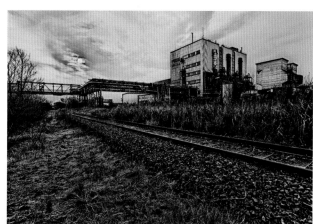

Artistic Presets

The other category of presets to turn to for hyper-reality are those organized under the Artistic heading.

Step 1: The Artistic preset category contains a number of useful options for the hyper-real artist. Structurized Skies, for example, emphasizes texture and layers in cloudy skies, setting a hyper-real tone for the rest of the image.

★ 08 Structurized Skies

Preset Categories

All	Landscape
Realistic	Architecture
Artistic	Special
Surreal	Favorites

Step 2: With no adjustment the Texturized Skies preset, although emphasizing the sky, has resulted in a dark, somewhat drab looking image. To counter this in the Global Adjustments controls I increased Saturation from −10 percent to 25

percent, reduced the Blacks setting by 10 percent to lower the black point, while increasing the Whites slightly. Both these adjustments help to lighten the image. I then reduced the Warmth slider to cool down the image.

✓ GLOBAL ADJUSTMENTS

Exposure	−0.4 EV
Contrast	15 %
Saturation	25 %
Structure	0 %
Blacks	−73 %
Whites	−30 %
Warmth	−43 %

HDR Method

Fresco

Method Strength	37 %

Step 3: To finish the image, I again added Control Points, this time in the foreground. With each Control Point I increased exposure to lighten the area, while also increasing the Contrast and Structure settings to make the most of the grassy texture.

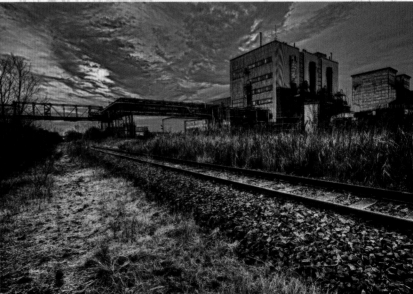

Preset Categories

All	Landscape
Realistic	Architecture
Artistic	Special
Surreal	Favorites

Search Results (6)

★ 00 Default

Realistic Presets

Another effective approach for a hyper-real image is to start with the Default preset found in Realistic. This creates an evenly balanced image on which you can apply custom settings.

From the Default settings, which sets to zero all the Global Adjustments, I increased Exposure, Contrast, Saturation, and Structure.

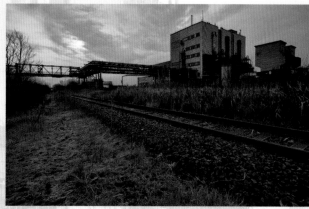

One Control Point to reduce the exposure and enhance the texture in the sky completed the image.

GLOBAL ADJUSTMENTS

Exposure	0.44 EV
Contrast	3 %
Saturation	63 %
Structure	74 %
Blacks	0 %
Whites	0 %
Warmth	0 %

Levels and Curves Neutral

Details

RGB

Reset

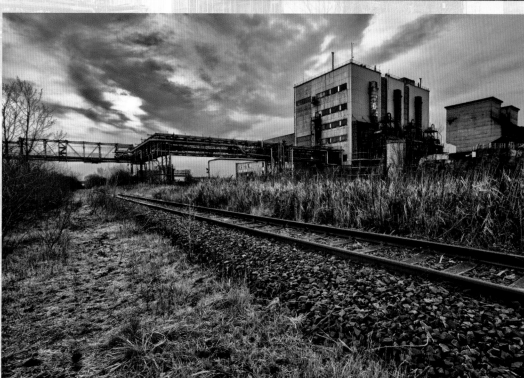

Having given the default image more impact using the Global Adjustments controls, the principal tonal improvement was performed using the Levels and Curves command in the Finishing Adjustments section. A gentle "S" curve increased contrast.

Oloneo PhotoEngine

PhotoEngine, being the most recent of the HDR programs covered here, is already gaining a reputation for producing clear, high-quality photorealistic HDR results, and the last chapter confirmed this.

However, creating surreal hyper-real HDR imagery is quite a different exercise. Much depends on the source sequence and the algorithms hidden behind the program's GUI.

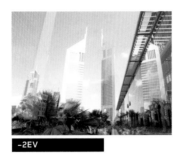
-2EV

Oloneo

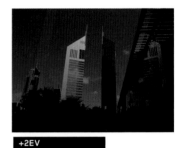
+2EV

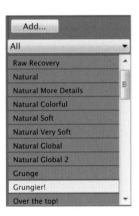

Add...

All

Raw Recovery
Natural
Natural More Details
Natural Colorful
Natural Soft
Natural Very Soft
Natural Global
Natural Global 2
Grunge
Grungier!
Over the top!

As we have with the other programs, let's first turn to PhotoEngine's presets to see what we can achieve with one click of the mouse. Here the Grungier! option has instantly provided a hyper-real view of the Jumeirah Emirates Towers, although there are distinctive halos around the buildings that we need to remove.

High Dynamic Tone Mapping ❓

Advanced Local Tone Mapper		▾
TM Strength:		64
Detail Strength:		113
Auto-Exposure: ✓		
Exposure:		0.00
Fine Exposure:		0.00
Auto-Contrast: ✓		
Contrast:		0
Detail Size:		56
Detail Threshold:		0
Edge Sharpen:		100
Panorama Mode: ☐		

Using the Advanced Local Tone Mapper control provides us with all the tools we need to fix the halos without losing too much of the hyper-real nature of the image. The first option is to increase the Detail Size. This increases the size of the objects that PhotoEngine will classify as Details, around which localized tone mapping occurs. As you move the slider you'll see the shape, size, and definition of the halos shift. In this instance, I increased Detail Size to minimize the halos, then reduced the Detail Threshold to further eliminate them. Reducing the Detail Strength helped to remove the halos altogether, while still retaining the hyper-real quality of the image.

Low Dynamic Tone ❓

Exposure:		0.00
Brightness:		0
Contrast:		25
Linear Raw: ☐		
Saturation:		143

With the tone mapping settings finalized, I enhanced the illustrative look by increasing the Saturation slider in the Low Dynamic Tone control. The oversaturated colors help to further remove the image from reality.

PhotoEngine vs. Photoshop

Although from the outset our intention has been to avoid making direct comparisons between HDR programs, for the reasons given earlier, as an exercise it seems valid to run an alternative sequence through PhotoEngine.

The Emirates Towers' sequence, due to the clarity of the light and the fact that it contains numerous reflections of steel and glass has an inherent "other worldliness" to it. To get a better feel for how PhotoEngine performs at hyper-real imagery I'm going to use another sequence; one that has a different quality to the lighting and exhibits more complex textural components.

We're going to use the railroad sequence as this fulfills the criteria outlined above, and it will be interesting to see how differently PhotoEngine will behave compared with Photoshop.

After creating the 32-bit HDR image for this hyper-real image, rather than turning to one of the surreal presets, I chose Reset all, which zeros all the settings and creates a flat, evenly toned image on which I can choose my own settings.

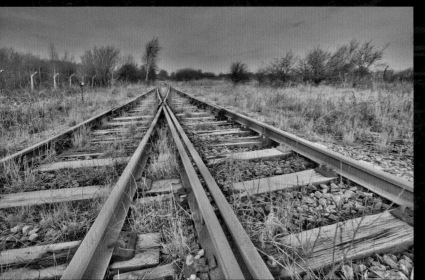

Next I selected the Advanced Local Tone Mapper option for maximum control and increased TM Strength to 100. This has compressed the tones in the image, resulting in a darker sky and brighter, more visible foreground.

Chapter 5 | Creating Hyper-real HDR Images | **PhotoEngine vs. Photoshop**

125

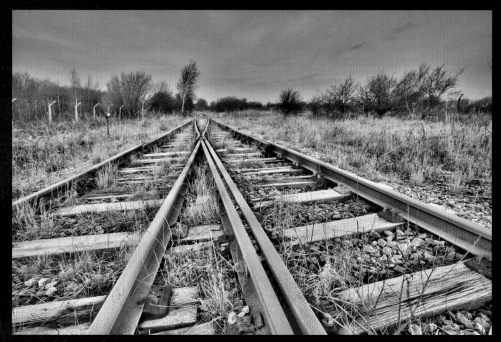

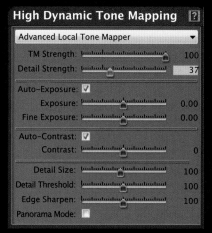

High Dynamic Tone Mapping [?]

Advanced Local Tone Mapper

TM Strength:		100
Detail Strength:		37
Auto-Exposure: ☑		
Exposure:		0.00
Fine Exposure:		0.00
Auto-Contrast: ☑		
Contrast:		0
Detail Size:		100
Detail Threshold:		100
Edge Sharpen:		100
Panorama Mode: ☐		

To maximize the detail and texture in the image, I increased the Detail Strength setting. Detail Strength controls micro-contrast and emphasizes texture.

However, increasing the setting has also made the halos around the trees in the background more prominent.

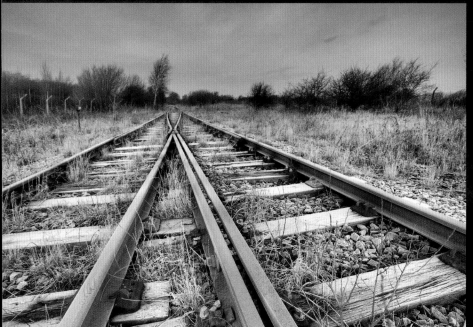

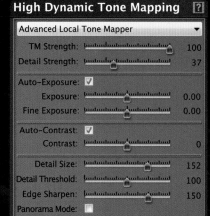

High Dynamic Tone Mapping [?]

Advanced Local Tone Mapper

TM Strength:		100
Detail Strength:		37
Auto-Exposure: ☑		
Exposure:		0.00
Fine Exposure:		0.00
Auto-Contrast: ☑		
Contrast:		0
Detail Size:		152
Detail Threshold:		100
Edge Sharpen:		150
Panorama Mode: ☐		

As in the last example, to combat the halos around the trees I increased Detail Size. The last tone mapping setting was to increase the Edge Sharpen setting, again to emphasize the textures of the sleepers, ballast, and grasses in the foreground.

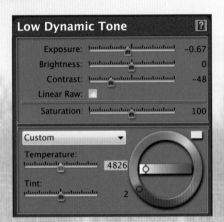

Before saving the image I made three final adjustments in the Low Dynamic Tone settings. I reduced Exposure slightly to add to the drama of the image. The second adjustment was a slight reduction in Contrast, which in this particular image rendered some of the detail in the bushes more visible, and finally I reduced the Temperature setting. This has made the image bluer, helping to reinforce the cold temperature in which the picture was shot.

Thanks to the level of control it has to offer, PhotoEngine has produced a credible hyper-real image with this particular sequence. In terms of general tonal distribution and the quality of the detail, this version is not that dissimilar from the one produced by Photoshop. One notable difference, however, was that I found it easier to get greater tonal variety in the sky in Photoshop without affecting the rest of the image, although it's impossible to tell how significant this is based on just one HDR image. Also, it's important to point out that, as we shall see in the final section, most HDR images will likely undergo one final post-production stage before they are ready to output.

Which Program?

Now that the programs have been used to create both photorealistic and hyper-realistic images, is there a clear winner?

Well perhaps not surprisingly, the answer is no—but nor was it ever the intention to perform a comprehensive comparison of the software—in fact there are a number of programs available that aren't covered here.

I think what is apparent now is that software developers have all learned a lot in the last few years about HDR and photographers' expectations. Looking at forums and reading articles in magazines would suggest there's a move away from the more surreal HDR imagery toward the photorealistic. Whether this is a long-term trend or simply fashion only time will tell.

HDR software seems to vary less in performance and output than it did a few years ago. Running the various sequences illustrated here using the different HDR programs showed the results to be surprisingly uniform, especially when attempting to produce photorealistic images.

Perhaps where there is greater difference is in the realm of hyper-reality. Although all the programs offer presets and controls that allow for the creation of this type of HDR shot, Photomatix Pro and HDR Efex Pro perhaps offer more artistic variation, with the caveat that the results may need remedial work, often in the form of noise reduction during post-production. This is something that is covered in the next section.

Photoshop and PhotoEngine arguably are better suited to photorealistic imagery, and both produce very clean looking results. Both programs offer a good level of control, and it's often difficult to tell which program has created which final image.

HDR Express, despite being aimed at those new to HDR photography, is also a very capable program, but like Photoshop and PhotoEngine, is perhaps more capable of photorealistic results than anything truly surreal.

◀

Grease monkey's habitat
Ben Willmore

Photomatix Pro 2.3
Details Enhancer
settings

Strength: 100

Color Saturation: 100

Luminosity: 10

Light Smoothing: Low

Microcontrast: High

White Point: 0.000000

Black Point: 1.835000

Micro-smoothing: On

▶

Heavenly reflections
John Maslowski

Photomatix Pro 2.4
Details Enhancer
settings

Strength: 100

Color Saturation: 72

Luminosity: -6

Light Smoothing:
Medium

Microcontrast: High

White Point: 3.107100

Black Point: 5.000000

Gamma: 1.057018

Micro-smoothing: 1

◄

Hong Kong from the peak on a summer's night
Trey Ratcliff

►

Bumby Arcade
Brooks Potteiger

▼◄

The Minton floor inside St Georges Hall
Pete Carr

◄

Boardwalk night
John Maslowski

Photomatix Pro 3.1
Details Enhancer settings

Strength: 96
Color Saturation: 27
Luminosity: 10
Light Smoothing: Medium
Microcontrast: 10
White Point: 0.000000
Black Point: 0.015100
Gamma: 1.453972
Temperature: 0
Saturation Highlights: 0
Saturation Shadows: 0
Micro-smoothing: 0
Highlights Smoothing: 21
Shadows Smoothing: 50
Shadows Clipping: 50

▼

The city windy
Brooks Potteiger

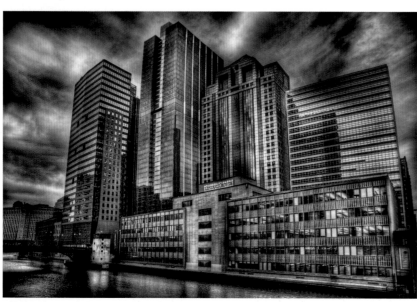

►

A private inaugural party - South Florida style
Michael Steighner

Photomatix Pro 3.1
Details Enhancer settings

Strength: 92
Color Saturation: 57
Luminosity: 10
Light Smoothing: Medium
Microcontrast: 8
White Point: 0.989300
Black Point: 2.931600
Gamma: 1.197479
Temperature: 5
Saturation Highlights: 1
Saturation Shadows: 0
Micro-smoothing: 1
Highlights Smoothing: 0
Shadows Smoothing: 0
Shadows Clipping: 0

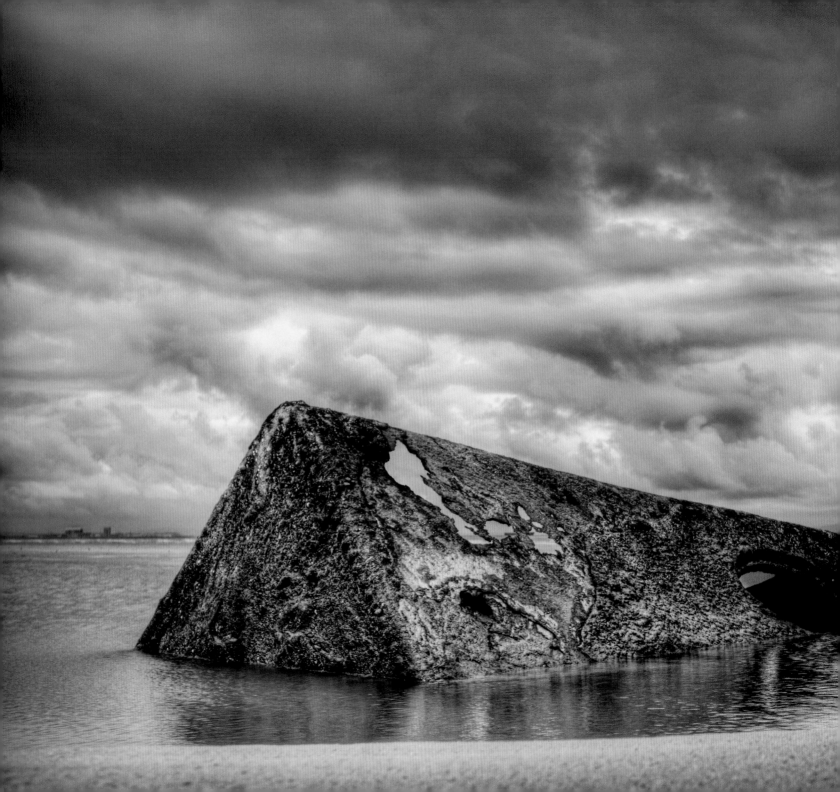

► *Shanghai up close*
Michael Steighner

Photomatix Pro 3.0
Details Enhancer
settings

Strength: 100
Color Saturation: 30
Luminosity: 8
Light Smoothing:
Medium
Microcontrast: 10
White Point: 0.000000
Black Point: 0.000000
Gamma: 0.823591
Temperature: 0
Saturation
Highlights: 0
Saturation Shadows: 0
Micro-smoothing: 8
Highlights Smoothing: 0
Shadows Smoothing: 0
Shadows Clipping: 0

◄ *At the end*
David Nightingale

Photomatix Pro 3.1
Details Enhancer
settings

Strength: 91
Color Saturation: 75
Luminosity: 7
Light Smoothing: High
Microcontrast: 0
White Point: 1.985700
Black Point: 1.270650
Gamma: 1.013960
Temperature: 3
Saturation
Highlights: 0
Saturation Shadows: 0
Micro-smoothing: 2
Highlights Smoothing: 0
Shadows Smoothing: 0
Shadows Clipping: 0

Chapter 6:

HDR Post-production

Removing Noise

−3EV

−2EV

−1EV

Metered exposure

+1EV

+2EV

+3EV

When HDR images first started appearing on the web, one of the things that was most often commented on was the amount of noise, especially in the darker areas of the final images. At the time, the novelty value of HDR was sufficiently high that this was often forgiven, but as the technique has matured, the audience has become less forgiving. In the case of an HDR image constructed from a bracketed sequence, much of the noise can be avoided if you make sure you provide adequate coverage of the tonal range from the outset.

This sequence was shot on an overcast day, using a 1EV spacing, and a three-shot sequence would have been sufficient to capture the entire dynamic range, with no clipping of either the highlights or shadows, so it looks like using these three shots to construct the HDR image—rather than the full seven-shot sequence—would be possible.

If you take a closer look, you can see that this would be a mistake. To illustrate this I used Photomatix Pro to produce three HDR images. The first was constructed

using three shots (−1EV, the metered exposure, and +1EV), the second used five images (−2EV to +2EV) and the third used all seven exposures, from −3EV to +3EV. Each of the resultant HDR images was then tone mapped in Photomatix Pro using identical settings. When they are enlarged (below), the noise is considerably more pronounced in the three-shot version, a bit better in the five-shot one, but best of all in the seven-shot version because the lightest shot of the sequence—+3EV—recorded more data in the shadows.

More recent versions of Photomatix Pro (version 4 onward) feature Preprocessing Options, including Reduce noise. The dialog provides a Strength slider and a dropdown menu that allows you to choose which exposures to apply the noise reduction to. It is a good idea to apply the noise reduction to the source files rather than the merged image. The latter uses a less effective algorithm.

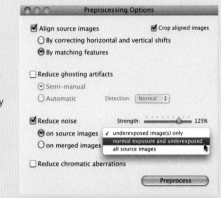

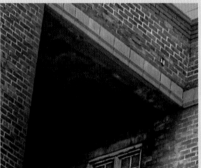

Produced using seven exposures and noise reduction

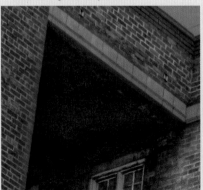

Produced using three exposures

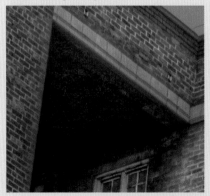

Produced using five exposures

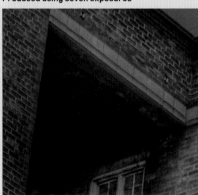

Produced using seven exposures

No Noise Reduction in Lightroom before exporting

Noise Reduction applied in Lightroom before exporting

Noise Reduction using Raw editor

For HDR programs that don't have a noise reduction pre-processing option, there is an alternative method for combating a noisy image sequence. Before merging the Raw files, open the metered and underexposed images in a Raw editor and check for noise in shadow regions. Use the editor's noise reduction controls to remove as much of the noise as possible without compromising detail. When you export the Raw files to be merged in the HDR software the Raw editor will apply the noise reduction to the converted TIFFs, resulting in a less noisy HDR file.

If your HDR software doesn't function as a Raw editor plug-in, save the files as TIFFs from the Raw editor in a separate folder, open the HDR software and navigate to the folder in the usual way.

If you find that there is still some noise in the tone mapped image you have four choices. If the noise is minimal, and confined to only a few small areas, you can probably ignore it as it won't be obvious to anyone other than the most diligent of observers. Alternatively, if the

noise is only visible in the very darkest areas of the image you could use a Curve to clip the shadow detail slightly, making these areas of the image black, and obscuring the noise. A further option would be to blur the noise in Photoshop to disguise it, and the final solution is to use a noise reduction plug-in in Photoshop. It's the two last solutions that I will look at here.

Adding blur in Photoshop

Blurring noisy areas of an image is a relatively straightforward task. The first thing to do is duplicate your image layer, either by right-clicking the background layer in the layers palette (and selecting Duplicate Layer), or via the Layer menu (*Layer>Duplicate Layer*). Having created a duplicate layer, zoom in to a 100 percent preview (*View>Actual Pixels*) so you can see the noise clearly.

At this stage you're ready to add some blur. There are a variety of blur filters available within Photoshop but the one I would recommend is Gaussian Blur (*Filter>Blur>Gaussian Blur*). The dialog for this filter is minimal—the only setting you

can change is the radius. For most high resolution images, a setting of around 1 pixel is sufficient to remove the majority of the noise, but you might want to lower this value (in 1/10 increments) if the noise is relatively weak, or use a higher value if it is especially pronounced. As you adjust the setting you can see the result in the small preview window within the dialog, but you can also preview the whole image if you have the Preview button checked.

Once you find a value that blurs the noise by a sufficient amount, press the OK button to apply the filter. This softens the entire image, including areas that would be better left sharp (such as the windows and brickwork in this example). This is easily remedied—either erase the bits you don't want blurred (using the Eraser tool), or add a Layer Mask and paint over the areas of the mask where you would like the original, unblurred layer to show through.

Using the Eraser will produce smaller files, because you are physically removing data in the blurred layer, while masking allows you to revisit the changes you make so you can more precisely edit where the blurring is applied.

Using noise removal plug-ins

As well as manually removing noise using Photoshop's blur filters, there are a variety of plug-ins available, all of which offer a range of automatic and semi-automatic ways of reducing noise. The two I use most often are Noise Ninja and Noiseware Professional. Both of these are a better alternative to the manual blurring technique because they analyze the image to identify noise, rather than applying a global alteration. This means the noise reduction is performed without compromising the fine detail in other areas of the image.

They also provide a greater range of settings that can be tweaked and adjusted to provide the best possible noise reduction for each image you are working with. In the case of Noise Ninja you can alter a wide range of settings including the Strength and Smoothness of the filter, and the Contrast and Sharpness of the final image. You can also use a "noise brush" to apply the noise control to specific sections of your picture.

Noiseware Professional, on the other hand, offers a range of presets to choose from, each of which is tailored to a particular style of photography, such as landscapes, night shots, and so on. However, you can also change the intensity of noise reduction applied to different tonal areas, allowing you to target shadow noise without affecting the midtones or highlights, for example.

Photomatix Pro 3.0
Details Enhancer
settings

Strength: 100
Color Saturation: 21
Luminosity: 10
Light Smoothing: Medium
Microcontrast: 10
White Point: 0.000
Black Point: 0.000
Gamma: 0.77
Temperature: 0
Saturation Highlights: -2
Saturation Shadows: 0
Micro-smoothing: 2
Highlights Smoothing: 0
Shadows Smoothing: 0
Shadows Clipping: 0

Removing Halos

One of the difficulties you will face when tone mapping your HDR images is that the process will often introduce halos around objects within your pictures, most commonly when they are set against a much lighter background. Clearly, the easiest way to deal with this problem is to avoid generating them in the first place, but with some images this just isn't possible, at least not without producing a much less interesting image. For these two Photomatix Pro tone mapped images of a disused railway line, one was produced using Very Low Light Smoothing (top), while the other used a High Light Smoothing setting (bottom).

The one produced with the Light Smoothing set to Very Low is clearly a better image—at least in terms of the foreground detail—and it makes the other version looks very dull and flat. What you will notice, though, is the considerable amount of haloing along the horizon and around the large tree at the right. In some cases, a minor amount of haloing isn't an issue, but in this instance the effect is far too pronounced to be acceptable. So, it's a choice of accepting a weaker, flatter image with High Light Smoothing, or correcting the haloing in an image-editing program, which is what we will do here.

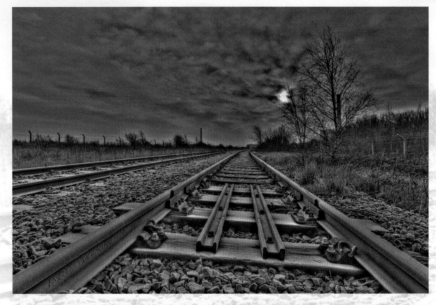

Photomatix Pro 3.1
Details Enhancer settings

Strength: 100
Color Saturation: 28
Luminosity: 10
Light Smoothing: Very Low
Microcontrast: 10
White Point: 0.000
Black Point: 0.000
Gamma: 1.13
(other settings left at default levels)

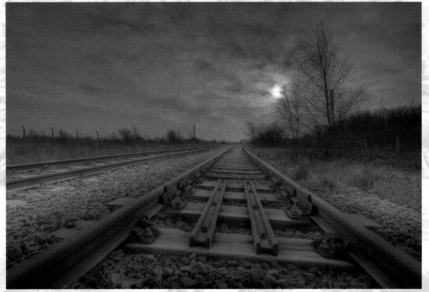

Photomatix Pro 3.1
Details Enhancer settings

Strength: 100
Color Saturation: 28
Luminosity: 10
Light Smoothing: High
Microcontrast: 10
White Point: 0.000
Black Point: 0.000
Gamma: 0.65
(other settings left at default levels)

The way to do this in Photoshop (and most editing programs) is to use the Clone Stamp Tool to replace the lighter (halo) sections of sky with the darker sky above it. Once you have selected the Clone Stamp Tool you need to select an appropriate Master Diameter (size) and Hardness for the tool by right-click-ing within the borders of the image to open the tool options dialog. Pick a size that's appropriate to the area you want to change, and a Hardness of 0 percent, as this will make sure that the alterations you make to the image are blended smoothly.

The next stage is to pick a "source" area to clone from, which is the area of the image that will be used to replace the lighter halo. Hold down the Option key (the cursor will change to a target symbol) and click the area you want to select.

Once you have selected your source area, move your cursor to the "target" area (the area containing the content you want to remove) and click. When you do, this simply paints over the area of the image you want to change with the source area.

However, to darken the halos, rather than simply replacing one area of the image with another, there is one further step you need to take.

Some of you may prefer to carry out the same procedure using the Healing Brush tool. This tool works in much the same way as the Clone Stamp tool, but differs in that it blends the cloned pixels with those you are cloning over. This too is a perfectly good way of achieving the same result.

The Clone Stamp Tool Altering the size and hardness of the Clone Stamp Tool

Picking a source point

Cloning

The key to only correcting the halos is to change the blending mode of the Clone Stamp tool from Normal to Darken, using the Effect Mode dropdown menu in the toolbar. When you change the blend mode to Darken, Photoshop evaluates the brightness of the target area in relation to the source area and only darkens areas that are lighter. Areas that are already darker, such as the foliage and fence in this example, are left at their original value.

The end result, providing you make sure that you don't inadvertently clone out any detail that should be in the image, is that the halos will be removed. The benefit of this technique is that it lets you produce a more dramatic image at the tone mapping stage, which you can subsequently fix, rather than having to accept a less impressive image from the outset.

Cloned using the Darken blending mode

Photomatix Pro 3.1
Details Enhancer
settings

Strength: 100
Color Saturation: 28
Luminosity: 10
Light Smoothing:
Very Low
Microcontrast: 10
White Point: 0.000
Black Point: 0.000
Gamma: 1.13
(other settings left
at default levels)

Enhancing Contrast Using Curves

One of the biggest problems you will encounter with your tone mapped images—especially if you're aiming to produce a more surreal final image— is that the initial result can often appear quite flat, with "muddy" shadows and highlights that don't really sparkle. If you look at the example below you will see what I mean; the tone mapped image is dull in comparison to the final image. Yet the only difference between the two images is the application of a Curve in Photoshop—a single edit that can transform a picture.

The Curves tool lets you make simple adjustments to the tonal range of an image. It also provides an exceptionally high level of control as it lets you manipulate both the white and black points, plus fifteen additional anchor points that can be positioned anywhere within the original image's tonal range.

To use the Curves tool you need to either select it from the Image menu (*Image> Adjustments>Curves*) or create a Curves adjustment layer (*Layer>New Adjustment Layer>Curves*).

The default points on the curve are at the very ends of the line—the top right and bottom left corners, which represent the white and black points in the image respectively. By shifting the anchor points from their starting positions the white and black points can be adjusted to darken shadows and brighten highlights.

Adjusting the white and black points makes the Curve (which is currently a straight line) steeper. This stretches, or expands, the tones in an image, increasing the overall contrast. Conversely, if you decrease the slope, you compress the tonal range and reduce the contrast in the image.

Original tone mapped image

Final tone mapped image with adjustment curve

The Curves tool can also be used to adjust the midtones in an image. To do this, you need to add an anchor point to the Curve, by clicking the position on the Curve where you want to insert it. To control the midtones, this needs to be roughly halfway between the black point and white point. If you drag this anchor point toward the top-left corner of the dialog it will increase the brightness of the midtones, while dragging it down toward the bottom-right corner will decrease the brightness. The further you drag the anchor point, the greater the brightening or darkening effect.

Lightening the midtones

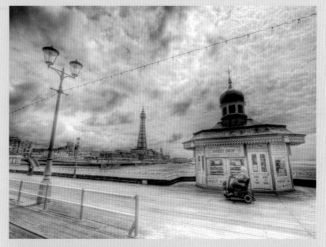

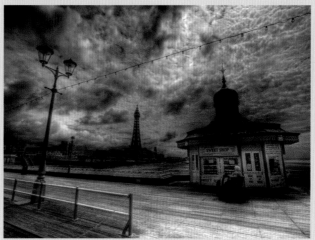

The Curves dialog

Adjusting the black point

Adjusting the white point

Darkening the midtones

A basic S-Curve

The most common Curve—the S-Curve—boosts contrast in an image without clipping. The shape of the S, and the position of the two anchor points determines the effect of the curve.

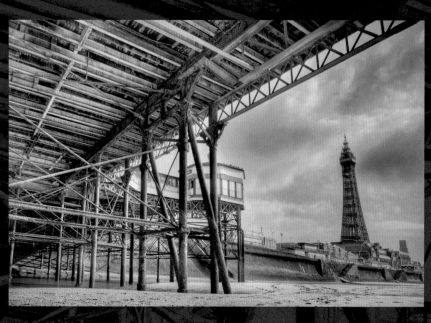

Increasing contrast in the shadow areas

Working with S-Curves

One of the most useful Curves is typically referred to as an S-Curve, because it is in the shape of a flattened letter "S." Typically, an S-Curve will have two anchor points—an upper point to lighten the lighter parts of the image, and a lower point to darken the shadow areas, as shown in the examples above. This increases the contrast in an image, but because the white and black points in the Curve aren't usually moved, there's no risk of clipping the shadows or highlights.

How to construct a Curve

As previously noted, the steeper a curve, the greater the increase in contrast. However, when working with S-Curves, not all of the Curve can be steep—both ends become progressively more shallow as they move toward either the white point or black point. This means you need to decide which sections of the Curve to make steep, and which to make more shallow. For example, if your aim is to maximize the contrast in the darker areas of the image, then the steepest section of the Curve should be toward the bottom-left corner—the shadow/ black point end. This will expand the tonal range in the shadow areas of the image which, in this case, really brings out the detail under the pier (above). What you will also notice is that the contrast in the lighter areas of the original image—the sky and brighter sections of structure— is now much lower. This is because the section of the Curve toward the top right that controls the highlight detail is now much flatter.

Alternatively, if you decided that you wanted to maximize the contrast in the highlight areas, you could set your curve accordingly. In this instance, the steepest section of the Curve needs to be toward the top-right corner of the dialog to expand the tonal range in the highlight areas, while decreasing the contrast in the darker areas (opposite, top).

Ultimately, it is this control that makes the Curves tool something you will certainly want to explore further when modifying your LDR images. Initially, it can be a little tricky to get to grips with Curves, and there are no clear guidelines I can give you as each image is different, and each requires adjusting in a different way. A gentle S-Curve is often a good place to start, but beyond that it only becomes easier to use with practice.

**Increasing contrast
in the highlight areas**

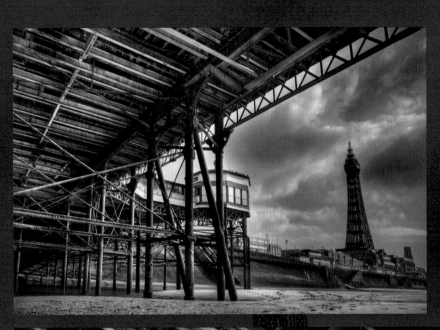

Before Curves adjustment

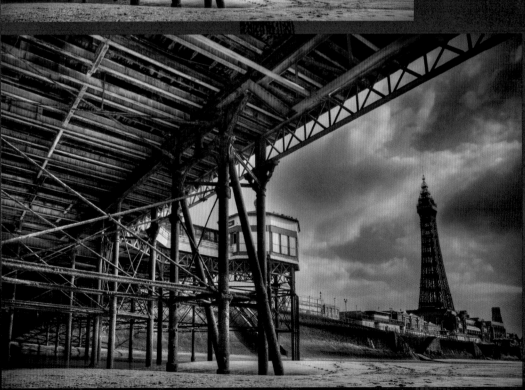

After Curves adjustment

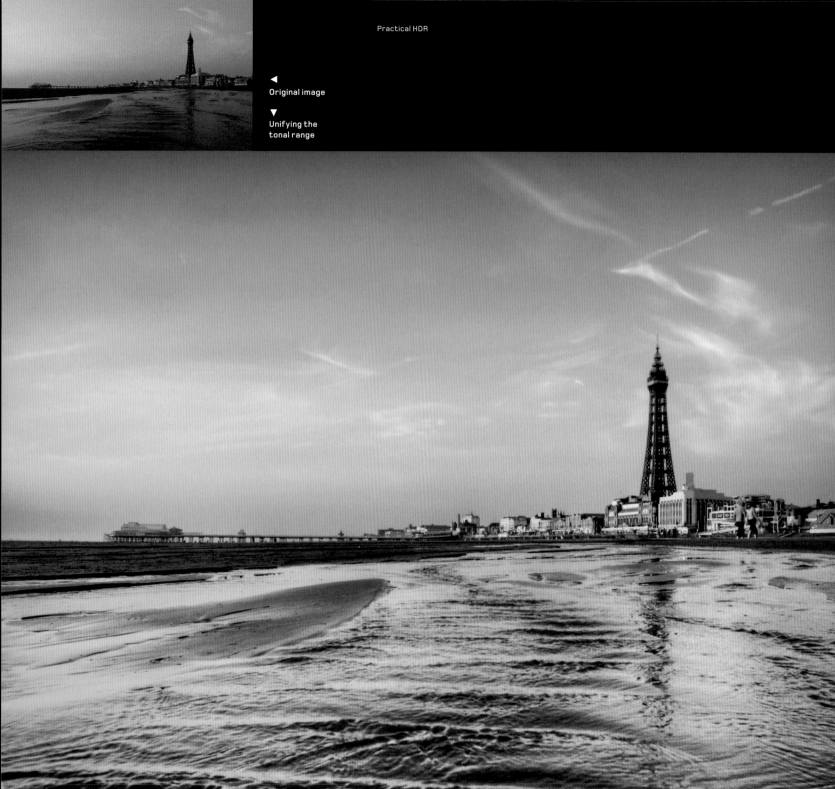

◄
Original image

▼
Unifying the
tonal range

Creating Single Image HDRs

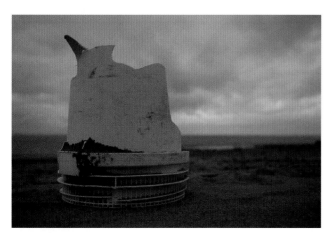

Original image

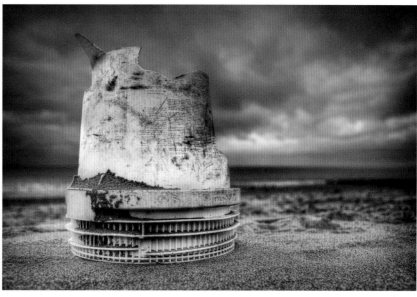

Maximizing local contrast

So far, all of the techniques we have looked at center on producing a final image from a bracketed sequence of shots, but it is also possible to tone map a single Raw file using most HDR software. However, as starting with a bracketed sequence will nearly always produce a better result, why would you want to use this technique?

The first, and simplest, answer is that it allows you to create the HDR "look" without the need for a series of bracketed exposures. This means it can be applied to any Raw file you may have taken.

Second, it provides a relatively straight-forward way to unify the tonal range

within an image, so you can balance the foreground illumination to the sky, for example. Also, because this technique maximizes the local contrast, it can be used to bring out every last detail within an image, without the need for complex masking and selective adjustments.

Finally, there are times when it simply isn't possible to shoot a bracketed sequence—such as when the subject is moving. These reasons are not exclusive to one another—you can create the HDR look, unify the tonal range, and maximize detail at the same time—but there are several ways you can increase your chances of producing a final image with as little noise and as few processing artifacts as possible.

Optimizing the exposure

The key to a successful HDR image constructed from a set of bracketed exposures is to shoot a sequence that covers the entire dynamic range of the original scene, and the same holds true for a single-image HDR. In this instance, though, you only have a single exposure to work with, so you ideally need to make sure that the dynamic range of the scene is lower than your camera's dynamic range from the outset—any shadow or highlight clipping at the exposure stage will be carried through to the final image.

Tone mapped directly from Raw file in Photomatix Pro.

Converted from Raw to 16-bit TIFF using Adobe Camera Raw, then tone mapped in Photomatix Pro.

Converted from Raw to 16-bit TIFF, with increased noise reduction.

Pre-processing an image

When working with a bracketed sequence of exposures I would recommend that you work with Raw files whenever possible, but for single image HDR's this can cause problems, particularly in terms of introducing unwanted noise. The image opposite was tone mapped twice in Photomatix Pro; first from the original Raw file, and then from a 16-bit TIFF generated using Adobe Camera Raw's default settings. The tone mapping settings were the same for each version.

If you look at the details from these two conversions (opposite, bottom left, and bottom center) you can see that the noise in the dark area is obvious in the image that was tone mapped directly from the Raw file, although this doesn't have any impact on the area in the center of the car's hood. Conversely, there is considerably less noise in the darker areas of the tone mapped TIFF.

The reason for this is the noise reduction algorithms in Camera Raw are more sophisticated than those in Photomatix Pro, so tone mapping a pre-processed Raw file produces a much cleaner final image. What you may also have noticed though, is that the lighter area in the TIFF image now looks a bit softer.

The TIFF file was initially created with Camera Raw's default noise reduction settings (Luminance: 0 and Color: 25), and if we increase the amount of noise reduction—in this instance to Luminance: 50 and Color: 50—the darker areas of the image are almost entirely free from noise (opposite, bottom right). At the same time, though, this removes a noticeable amount of detail from the highlight areas.

The problem here is that there is no reliable way of working out how much noise reduction you need to apply to prevent noise in the shadow areas of the final tone mapped image. This is because the amount of noise is proportional to the strength of the tone mapping you apply, and the areas of the image that will be affected the most are the darkest areas, which are inherently difficult to evaluate, precisely because they are so dark. My advice is to use the default noise reduction settings, but be prepared to produce a version with a higher amount of noise reduction if necessary. Alternatively, if there is still some residual noise in your image, remove it using a noise reduction plug-in, such as Noise Ninja.

Generating a pseudo-HDR image

Once you have adjusted the Raw file in the Raw editor you can either export it to your HDR software (in which case it will be converted to a TIFF automatically) or save it as a 16-bit TIFF and open it in the HDR software. Either action will result in the generation of a pseudo-HDR image.

Tone mapping a single file is done in exactly the same way as tone mapping a bracketed sequence, but you should note that because pseudo-HDR files contain less data than an HDR file generated from a bracketed sequence of exposures, they often need to be processed more conservatively, so you may not be able to produce as dramatic a final image as you would like without introducing obvious processing artifacts.

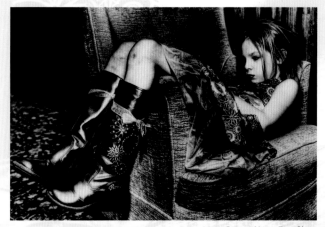

Converting a Raw file to black and white, and then tone mapping the monochrome file can produce great results.

Enhancing Low Contrast Scenes

| Shadows | Midtones | Highlights |

Pixel Count >

−2EV

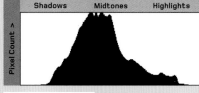

| Shadows | Midtones | Highlights |

Pixel Count >

Metered exposure

| Shadows | Midtones | Highlights |

Pixel Count >

+2EV

The majority of HDR techniques involve creating images from scenes with an EV range exceeding that of your camera, but they can also be used to enhance scenes with a lower EV range that could be captured in a single shot.

The histograms for the three images of a disused piercing parlor used here show that the metered exposure captures the full EV range of the original scene. Simply increasing the contrast for the metered exposure produces an acceptable image (right), but it's quite different to a tone mapped version created from all three frames (opposite).

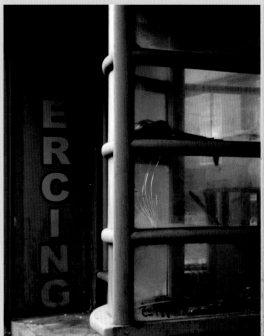

A Curves adjusted version of the metered exposure

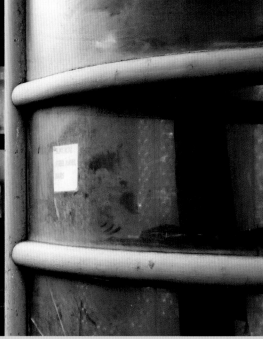

The top section of the sign on the left of the image is much darker in the version constructed from the metered exposure, while the text on the small piece of paper in the window is much clearer in the tone mapped version. There is also a lot more fine-scale detail in the tone mapped image, which is most noticeable in the brighter sections of the windows where you can see every scratch and smear. Overall, the tone mapped version has a much more evenly distributed range of tones than the metered exposure.

Shooting a low contrast scene is a lot easier than shooting a scene with a high EV range, because a three-shot brack- eted sequence cannot fail to capture the entire EV range of the original scene. All I would suggest is that you check the histogram of your metered exposure to make sure it isn't especially biased to either the highlight or shadow detail, then shoot a three-shot sequence using a 2EV spacing. Once you have generated your HDR image you are ready to move on to the tone mapping.

Again, you can proceed with this stage of the process much as we have in previous sections of the book, adjusting the various sliders and controls until you are satisfied with the result. In practice, your aim will be to unify the tonal range of the different areas of the original scene, although each image is different, so each will require some fine-tuning of the settings to produce the best result.

TOWER HAMLETS COLLEGE
POPLAR HIGH STREET
LONDON
E14 0AF

The tone mapped image

-3EV

-2EV

-1EV

Metered exposure

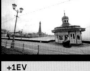
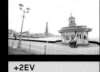
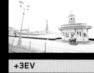

+1EV

+2EV

+3EV

"Moderate"
tone mapping

Photomatix Pro 3.1
Details Enhancer
settings

Strength: 71

Color Saturation: 17

Luminosity: 3

Light Smoothing: High

Microcontrast: 10

White Point: 0.000

Black Point: 0.015

Gamma: 0.58

Micro-smoothing: 12

(other settings left
at default values)

Up until this point, the workflow we have followed (other than discussing how to tone map a single image), has followed much the same pattern:

- Shoot a bracketed sequence of exposures of the original scene.
- Create a 32-bit HDR file from the bracketed exposures.
- Tone map the HDR file into an 8-bit or 16-bit LDR file.
- Carry out post-production.

For the most part, this four-step workflow is all you need, and it works well with most image sequences. However, there are times when the tone mapping stage can be problematic, and trying to determine which settings to use isn't clear-cut.

As you can see from the original set of exposures for this image, this scene would have been very difficult to

photograph in a single shot, as in the metered exposure the sky is clearly overexposed, yet the small building is very dark. This is clearly an ideal scene for creating an HDR image, but what tone mapping settings should you use? If you take a look at the examples opposite and below, you can see that one version is much more extreme than the other, and if you look at the settings for the two versions, you can see why.

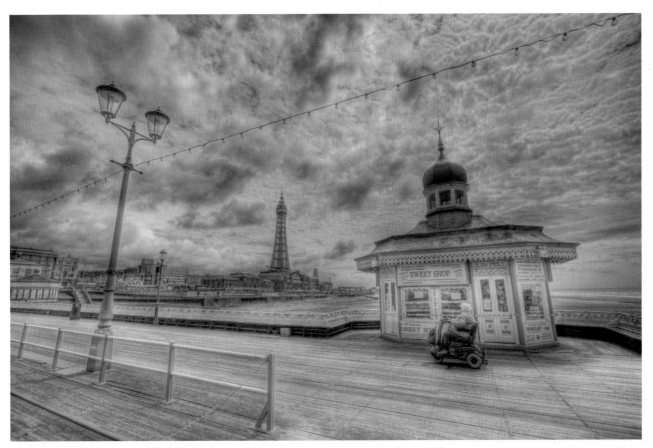

"Extreme" tone mapping

Photomatix Pro 3.1

Details Enhancer settings

Strength: 100

Color Saturation: 17

Luminosity: 10

Light Smoothing: Medium

Microcontrast: 10

White Point: 0.000

Black Point: 0.015

Gamma: 0.58

Micro-smoothing: 2

(other settings left at default values)

At this stage, both versions lack contrast, but this can be increased by adding a reasonably strong S-Curve. This clearly improves both images (below), and makes the sky even more dramatic in the extreme version.

You might prefer one version to the other at this point, in which case you could simply produce one tone mapped image using the settings of your choice. But if you think there are aspects of each version that have merit things get a bit more complicated. For example, while I like certain elements in the extreme version—the detail on the pier, the light on the small building, and the woman in front of it—the sky is a bit too dramatic, and draws the viewer's attention away from the foreground.

Based on what we have discussed so far, this leaves us with three choices; we can go with the extreme version, and accept that we don't much like the sky; we could use the more moderate settings and sacrifice some of the detail in the foreground; or we could try tone mapping settings that are a compromise between the two extremes. But, if we aren't entirely happy with either image, and don't want to "compromise" on the picture, there is a fourth option that will let us retain the best aspects of both versions: we can merge both tone mapped images in Photoshop and take the best parts of each one.

To do this you first need to create both tone mapped versions of the image and save them as 16-bit or 8-bit TIFF files.

Having generated a pair of tone mapped images, open both images in Photoshop. *Select the extreme version (Select>All)*, switch to the moderate image file, then click *Edit>Paste* to paste the extreme image as a new layer, immediately above the background layer of the original document. If your layers palette isn't visible, choose *Window> Layers*. This will show the two layers in your document: "Background" and "Layer 1" (1).

At this stage the moderate version won't be visible because the upper layer is concealing it, so we need to merge the two versions. To do this, add a Layer Mask to the new layer (*Layer>Add Layer Mask> Hide All*). This adds a black Layer Mask to the layer (2), and the Background layer is the one that is visible.

Moderate version with curves adjusted

Extreme version with curves adjusted

that the Layer Mask is active, not the content of the layer—the active element of the layer is indicated by a broken border around its thumbnail in the layers palette (3).

You can now start erasing areas of the Layer Mask, but there are a few things you should bear in mind with the Eraser tool, namely the size and hardness of the brush you use, and its opacity.

To control the size and hardness of the Eraser tool, right-click on your image to bring up a dialog that lets you change

want to retain.

The hardness setting refers to how defined the edge of the eraser will be when removing areas of the mask. A hardness setting of 100 percent has a clearly defined edge, while a hardness setting of 0 percent does not, making the blend much smoother (4). In practice, it's almost always better to use a "softer" brush with a setting closer to 0 percent than 100 percent, as this will mean that the changes are applied in a more natural way.

1

Pasted layer

2

Layer Mask added

3

Layer active

Layer Mask active

4

The hardness of the
Eraser defines the
sharpness of its edges

With this image, the aim is to remove the section of the mask at the bottom of the picture, so the more extreme version is visible in this area. This will produce a picture that combines the detail in the foreground of the more extreme version with the moderate sky.

As you erase the mask you can change the Opacity of the eraser using the slider on the toolbar. The Opacity controls the strength of the eraser, and set to 100 percent it will completely erase an area of the mask when you click on it, allowing the underlying image to show through fully. However, if you set the opacity to 50 percent, only half of the area you click on will be erased, so in this example the result would be a patch that is half "extreme" and half "moderate." By varying the Opacity as you work, you can control more precisely the blending of the two images.

While this blending technique is clearly a time-consuming one—not least because you need to produce two (or more) tone mapped versions of your HDR image to start with—it can be used to great effect, especially when the only other alternative is to produce an image that compromises the detail in one area to avoid making another area look too extreme. Compared to both the extreme and moderate tone mapped versions of the original image, my finished picture is clearly "the best of both."

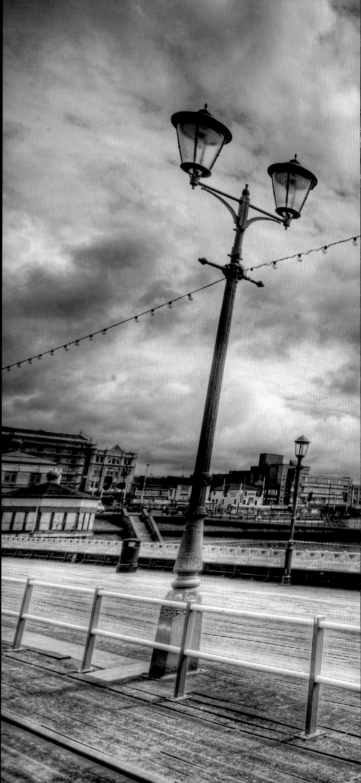

Merging Tone Mapped and Source Images

While there may be times when you want to merge two HDR images to get the best of two different tone mapping results, equally there will also be times when you want to merge a tone mapped image with an original source file.

This is a common exercise in HDR imagery, and is usually performed to reintroduce an element from the source file, such as the sky, to the tone mapped image. Skies can often undergo strange color or tonal shifts when tone mapped—usually because they are much brighter than the rest of the scene. So to make the final tone mapped image look more realistic, the sky from one of the bracketed exposures (usually an underexposed version) is blended with the tone mapped image.

Another common reason for blending a source file with the tone mapped version is to remove ghosting artifacts. Although most HDR software now features some form of built-in deghosting algorithm, as we saw in the second chapter, some programs are better than others at addressing the problem. Blending a single frame from the source sequence with the tone mapped image can effectively solve the issue.

However, the example here is neither of those. It does show, however, two more common problems that can be solved by blending—noise and blown highlights.

Utilizing tone mapping settings that make the most of the textures in the wall and on these Krakow street signs has forced the highlights in the windows to "blow out" and also resulted in noise in the top left-hand corner, as the details (1 and 2) show.

Tone mapped image

1

2

Raw image opened in Lightroom

3

4

Undo Layer Order	⌘Z
Step Forward	⇧⌘Z
Step Backward	⌥⌘Z
Fade	⇧⌘F
Cut	⌘X
Coppy	⌘C
Copy Merged	⇧⌘C
Paste	⌘V
Paste Special	▶
Clear	
Check Spelling...	
Find and Replace Text...	
Fill...	⇧F5
Stroke...	
Content-Aware Scale	⌥⇧⌘C
Puppet Warp	
Free Transform	⌘T
Transform	▶
Auto-Align Layers...	
Auto-Blend Layers...	
Define Brush Preset...	
Define Pattern...	

The first step is to open both the Raw file and the tone mapped image in Photoshop. If you have both Photoshop and Lightroom, then the workflow is straightforward. Simply select the two images in Lightroom's Library, right-click on them and go to *Edit In>Open as Layers in Photoshop...* (3). If you don't use Photoshop and/or your image editor can't read the Raw format, save the file as a 16-bit TIFF, and navigate to both files using your image editor.

Once the images have opened in Photoshop, you may want to select Auto-Align Layers (4) under the Edit menu to ensure that the top layer sits perfectly over the second layer to avoid any potential ghosting or blurring.

The next stages are much the same as in the previous example, except here we're going to go about blending the images in a slightly different way.

Once the images have opened as two layers in Photoshop, make sure the tone mapped layer sits above the Raw image in the Layers panel. Next, click the Add Layer Mask icon at the bottom of the panel (5). This will create the familiar Layer Mask thumbnail next to the image. But this time you'll notice it's white, and that the Raw image underneath is rendered invisible. In this example, therefore, we're going to paint with black on the Layer Mask to gradually reveal the Raw image below.

5

6

7

Click on the Brush tool and set a suitable size. As with the Eraser tool in the last example, use a low Hardness value to paint the mask in a more natural way.

Next, because you're painting with black over the Layer Mask, make sure that the Foreground Color is set to black at the bottom of the Toolbox (6).

With the tone mapped layer selected in the Layers panel, and making sure the Layer Mask is active, start to paint over the elements of the image you want to replace with the Raw image layer below (7).

As you start to paint over the image, the Raw layer will gradually reveal itself. At the same time, you'll see gray/black being applied to the Layer Mask in the Layers panel (8). The density of the color reflects the density of the mask. In other words, the darker the Layer Mask the more the Raw layer beneath will be made visible.

Here I've deleted much of the left part of the tone mapped image, effectively replacing it with the less noisy, better exposed Raw image.

Right-click on the Layer Mask to bring up the Layer Mask menu. You can click Disable Layer Mask to toggle between the before and after effect (9).

With the noise and blown highlights painted out go to *Layer>Flatten Image* and save.

8

LAYERS

Normal ⬍ Opacity: 100% ▾

Lock: 🔲 🖌 ✛ 🔒 Fill: 100% ▾

👁 Krakow Street...

9

Disable Layer Mask

Delete Layer Mask
Apply Layer Mask

Add Mask To Selection
Subtract Mask From Selection
Intersect Mask With Selection

▲

*As Wednesday comes
to a close at the DNC*
Michael Steighner

▶

Lost capsule
Ben Willmore

Photomatix Pro 3.1
Details Enhancer
settings

Strength: 100

Color Saturation: 46

Luminosity: −2

Light Smoothing: High

Microcontrast: 10

White Point: 0.000000

Black Point: 0.000000

Gamma: 1.000000

Temperature: 0

Saturation
Highlights: 0

Saturation Shadows: 0

Micro−smoothing: 0

Highlights Smoothing: 0

Shadows Smoothing: 0

Shadows Clipping: 0

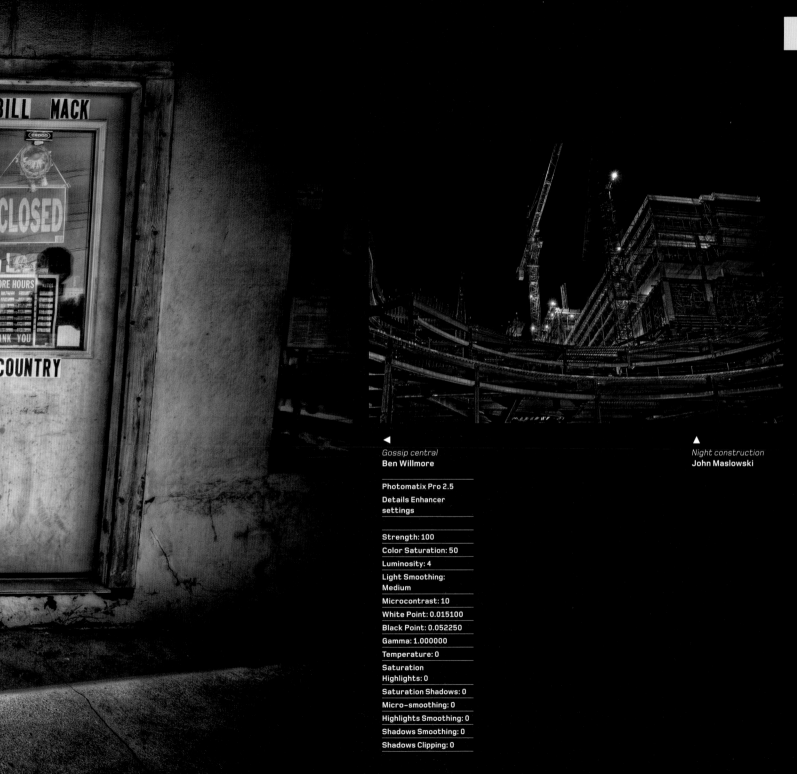

◄

Gossip central
Ben Willmore

**Photomatix Pro 2.5
Details Enhancer
settings**

Strength: 100

Color Saturation: 50

Luminosity: 4

**Light Smoothing:
Medium**

Microcontrast: 10

White Point: 0.015100

Black Point: 0.052250

Gamma: 1.000000

Temperature: 0

**Saturation
Highlights: 0**

Saturation Shadows: 0

Micro-smoothing: 0

Highlights Smoothing: 0

Shadows Smoothing: 0

Shadows Clipping: 0

▲

Night construction
John Maslowski

◀

*Through the
looking glass*
Ben Willmore

Photomatix Pro 2.5
Details Enhancer
settings

Strength: 77

Color Saturation: 43

Luminosity: –4

Light Smoothing: Very
High

Microcontrast: 10

White Point: 0.001800

Black Point: 0.036450

Gamma: 1.042466

Temperature: 0

Saturation
Highlights: 0

Saturation Shadows: 0

Micro-smoothing: 0

Highlights Smoothing: 0

Shadows Smoothing: 0

Shadows Clipping: 0

▲

Wyre wreck II
David Nightingale

Glossary

Auto-bracketing A method of automatically shooting a sequence of images to produce a set of differently exposed photographs that can be combined into an HDR image. While it is possible to auto-bracket using the shutter speed, ISO, or aperture, only the latter is useful for HDR photography.

Bit depth The number of bits (of data) that are used to record the data in your images. A JPEG file is encoded with 8 bits of data per channel, while a Raw file typically uses 12 or 14 bits of data (a decoded Raw file can contain 16 bits of data per channel). An HDR file contains 32 bits of data per channel.

Black point Within Photoshop, or other image-editing programs, the black point refers to the adjustment point that can be used to remap a particular point in the tonal range to black. In practice, this means that any value equal to, or lower than, the set value will be black in the final image.

Bracketing In HDR photography, bracketing refers to the process of shooting a range of exposures using different shutter speeds at a constant aperture to capture the entire dynamic range of the original scene. *See auto-bracketing.*

Clipping When shadows are underexposed, or highlights overexposed to the point that image detail is lost, they have been "clipped." This can be caused by selecting the wrong exposure or, in the context of HDR photography, when the dynamic range of the scene is larger than can be recorded by your camera's sensor.

Contrast ratio The ratio of brightness between the lightest and darkest tones in a scene or image. A typical camera's sensor can record a contrast ratio of up to 500:1 while the human visual system can adapt to a contrast ratio of 10,000,000:1.

Curves A feature in most image-editing programs, Curves adjustments are often used to increase the global contrast in a tone mapped image.

Details Enhancer The Details Enhancer is one of two methods of tone mapping that are available to you within Photomatix Pro. This method offers a high degree of control over the appearance of your final HDR image and is ideal when you want to produce a more surreal result.

Dynamic Range The dynamic range of a scene refers to the ratio between the luminance of the lightest and darkest areas of the scene. A scene with very bright highlights and deep shadows will have a large (or wide) dynamic range, while a shot with dull highlights and soft shadows will have a smaller dynamic range. When used to refer to a camera's sensor, dynamic range is often referred to in terms of the number of f-stops or the EV range that can be captured before the highlights or shadows become clipped. Most digital SLRs' sensors have a dynamic range in the region of 5–9EV.

Equalize Histogram Equalize Histogram is a method of tone mapping your images within Photoshop. For most HDR images this will often produce a tone mapped image with clipped highlights and shadows, so it is not a useful method in most circumstances.

Exposure Value (EV) Exposure Value is a term that denotes the combinations of shutter speed and relative aperture that give the same exposure. For example, an aperture of f/2.8 and shutter speed of 1/60 sec will give the same exposure as f/4.0 and 1/30 sec, so both have the same Exposure Value.

Exposure and Gamma Exposure and Gamma is a tone mapping option within Photoshop that allows you to control the highlight and midtone values within the tone mapped image.

Exposure Blending Combining an original sequence of bracketed exposures to produce a composite image derived from the dynamic range of the entire sequence. This isn't an HDR technique, but can be used to create a final picture from a scene where the EV range is much higher than your camera's dynamic range.

F-stop The f-stop is a ratio of the focal length of the lens to the diameter of the aperture. The value is in increments that allow half as much or twice as much light to reach your camera's sensor as the previous stop.

Ghosting Ghosting can occur within a tone mapped image when one or more components within the original scene moved between exposures, leaving faint traces, or "ghosts," in the final image.

Global contrast The overall contrast of an image. Adjusting the global contrast of an image changes all elements in the picture by the same amount.

Haloing Halos (lighter areas around the edges of objects) are artifacts introduced by the tone mapping process.

HDR or HDRI Abbreviations of High Dynamic Range and High Dynamic Range Images (or Imaging).

Histogram The histogram, either in-camera or within your image-editing software, provides a visual summary of the distribution of the tonal range within an image. This is an especially useful tool in the context of HDR photography.

Hyper-realism While HDR techniques can be used to produce photorealistic results, they can also be used to produce "hyper-real" images that have a more illustrative, or painterly appearance.

LDR Abbreviation of Low Dynamic Range. In the context of HDR photography, an LDR image refers to a picture with a dynamic range that can be captured and displayed on conventional LDR device such as a computer monitor or photographic paper. All HDR images are tone mapped to create LDR images for viewing or printing.

Local Adaptation The most useful method of tone mapping an image within Photoshop. Local Adaptation provides control over a variety of parameters including a tone curve to adjust the tonal balance of the final image.

Local Contrast The degree of contrast within specific areas of an image. Many tone mapping processes allow you to independently control local and global contrast, so distinct areas of the image can be adjusted individually.

OpenEXR A common file format for saving 32-bit HDR images as it preserves the data in the image.

Photorealism In the context of HDR photography a photorealistic image is one that is tone mapped to approximate the appearance of reality.

RGBE (Radiance) RGBE or Radiance is a common file format that can be used to save your 32-bit HDR images, although it can sometimes introduce slight color shifts in some images.

Tone Compressor A tone mapping operator in Photomatix Pro. This method can be used to produce photorealistic results from sequences of images where the EV range is high.

Tone mapping Tone mapping is the process whereby a 32-bit HDR image is converted into an LDR image. The large EV range of an original scene is compressed into an image that can be displayed and viewed using conventional LDR technology.

White point Within Photoshop, or other image-editing software, the white point refers to the adjustment point that can be used to remap a particular point in the tonal range to white. In practice, this means that any value equal to or higher than the set value will be white in the final image.

HDR SOFTWARE

Adobe Photoshop
www.adobe.com

Photomatix Pro
www.hdrsoft.com

HDR Efex Pro
www.niksoftware.com

HDR Express
www.unifiedcolor.com

PhotoEngine
www.oloneo.com

easyHDR
www.easyhdr.com

CONTRIBUTORS

David Nightingale
www.chromasia.com

Ricardo Aguilar Herrera
www.flickr.com/photos/fakefade/

Pete Carr
www.petecarr.net

John Maslowski
www.sirius2photo.com

Brooks Potteiger
www.brookspotteiger.com

Michael Steighner
www.mdsimages.com

Trey Ratcliff
www.stuckincustoms.com

Ben Willmore
www.thebestofben.com

Index